AN UNDERWATER GUIDE
TO HAWAI'I

Published in North America by
University of Hawaii Press
2840 Kolowalu Street
Honolulu, Hawaii 96822

Fifth printing in Malaysia 2000

Simultaneously published in Singapore by
TIMES MEDIA PRIVATE LIMITED
an imprint of Times Media Private Limited
a member of the Times Publishing Group
Times Centre
1 New Industrial Road
Singapore 536196
Fax: (65) 2854871 Tel: (65) 2848844
Email: te@tpl.com.sg
©1987 Times Editions Pte Ltd
©2000 Times Media Private Limited

Library of Congress Cataloging-in-Publication Data
Fielding, Ann
 An underwater guide to Hawaii

 Bibliography: p.
 1. Marine biology—Hawaii. I. Robinson, Ed.
II. Title
QH198 . H3F54 1987 591.9969 86-30841
ISBN 0-8248-1104-6

AN UNDERWATER GUIDE TO
HAWAI'I

*Ann Fielding
and
Ed Robinson*

University of Hawaii Press
Honolulu

Contents

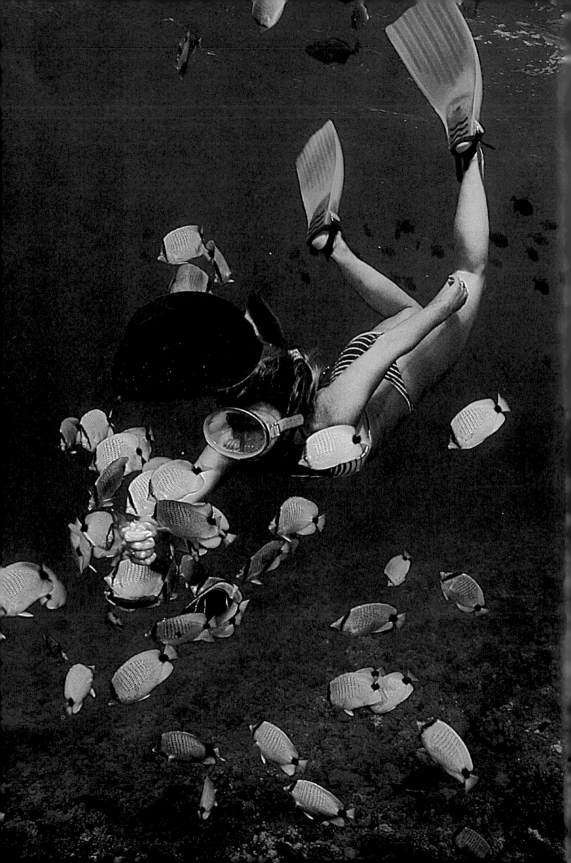

Foreword

The number of people involved in snorkeling and scuba diving in Hawai'i has increased phenomenally in the last few years. Along with this increased involvement in the marine environment has come a curiosity about the inhabitants and a need for accurate and easy-to-read information. It is our hope that this book will help fill that need for both residents and visitors. While other books in this series give more in-depth information on Hawaiian fishes and mollusks, this volume gives an overview of all types of marine life encountered by snorkelers and divers, as well as geological and zoogeographical information.

The names of the fishes are taken from John E. Randall's book *Underwater Guide to Hawaiian Reef Fishes*. Dr. Randall is senior ichthyologist at the Bernice P. Bishop Museum, and the major authority on Hawaiian fishes.

Ed Robinson took most of the beautiful photographs of Hawaiian marine life, and we are indebted to Jim Maragos, John Randall and Nancy Harris for providing others.

This book covers several areas of scientific expertise, and I would like to thank Jim Maragos, Bill Walsh, John Randall, Richard Grigg, Mike Hadfield, Isabella Abbott, Julie Bailey-Brock, Carol Hopper, Paul Wood and Ann Coopersmith for their comments and suggestions. Thank you, also, to the University of Hawaii Cartography Lab for their maps.

I would like to dedicate this book to the memory of the late Dennis Devaney, Ph.D. Dennis spent many years in the Department of Marine Zoology, Bernice P. Bishop Museum, Honolulu, studying the marine invertebrates of Hawai'i and the Pacific. He did much to further my knowledge and interest in the field of invertebrate zoology, and his loss is keenly felt.

Ann Fielding
Maui, 1986

Snorkeling and scuba diving are very popular sports around the Hawaiian Islands. Hawai'i offers clear, warm water and many species of colorful tropical fishes.

7

Formation of the Hawaiian Islands

Red-hot lava tumbling into a steamy sea, colorful tropical fishes swimming among delicate corals, rings of coral reef concealing ancient islands, these are the Islands of Hawai'i – geologically diverse, biologically unique. The Hawaiian Islands represent the tops of a chain of huge underwater mountains stretching almost 2,400 km across the North Pacific Ocean. At opposite ends of the chain, the land forms are quite different.

To the southeast are the eight main islands, containing 99 percent of the land area of Hawai'i, while to the northwest are largely coral atolls and a few volcanic remnants.

Beyond Kure Atoll at the north end of the Hawaiian chain lie the Emperor Seamounts, a series of underwater mountains that extend all the way to the Aleutian Trench.

Geologists have believed for many years that the Northwestern Hawaiian Islands are older than the main islands. Before modern technical methods of age-dating were available, scientists relied on observations of the physical characteristics of the islands, to determine their ages. A recently emerged volcano, such as Mauna Loa on the island of Hawai'i, or Haleakalā on Maui, has an unworn dome shape. In time, erosion takes its toll through the action of rain, surf, and the breakdown of rock into soil by plants, cutting deep valleys into the mountains. The steeply eroded contours of O'ahu and Kaua'i suggest that these islands are older than Hawai'i or Maui.

Another clue to the age of a tropical island is the amount of coral growth around it. Generally, the older the island, the more coral reef it has. We can look at reef deposits, their location and the thickness, and learn quite a bit about an island's history.

As soon as an island forms, tiny coral larvae settle on the hard volcanic rocks and begin the formation of reefs. The youngest type of coral reef is called a fringing reef and forms a limestone platform connected to the shoreline. The islands of O'ahu, Maui, Moloka'i and Kaua'i all have large amounts of fringing reef along their shorelines, but the much younger island of Hawai'i does not.

In time, the great weight of the island forces the earth's thin crust beneath the ocean to bow, and the island to slowly sink. Coupled with this general long-term pattern of subsidence (sinking) are the effects of sea level changes associ-

Various species of coral and coralline algae grow over basaltic rocks. In time, the rocks, coral, and sand will be bound together by the growth of coralline algae.

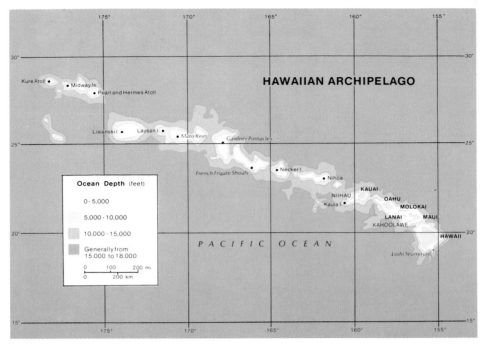

HAWAIIAN ARCHIPELAGO

Kure Atoll • Midway Is. • Pearl and Hermes Atoll

Lisianski I. • Laysan I. • Maro Reef Gardner Pinnacles

French Frigate Shoals • Necker I. • Nihoa

KAUAI
NIIHAU OAHU
Kaula I. • MOLOKAI
LANAI MAUI
KAHOOLAWE

PACIFIC OCEAN

HAWAII

Loihi Seamount

Ocean Depth (feet)

0 - 5,000

5,000 - 10,000

10,000 - 15,000

Generally from 15,000 to 18,000

0 100 200 mi
0 200 km

The Hawaiian Islands consist of the eight main islands and many reefs and atolls to the northwest. The Northwestern Hawaiian Islands are a wildlife refuge that is home to seabirds, sea turtles and the Hawaiian monk seal.

ated with the ice ages. Changes in sea level caused by subsidence and ice ages have a profound effect on coral reef development. During the glacial periods, sea level dropped almost 120 meters shifting the zone of reef growth further down the slopes of the mountains. During the interglacial periods (warm periods between the glacial periods) sea level rose, submerging these reefs and forming new ones at higher elevations. The islands of Kaua'i and O'ahu have large deposits of ancient coral reefs on dry land formed when the sea level was higher.

Coral reefs are made from a mixture of corals, coralline algae (limestone secreting seaweeds) and sediment. Both the corals and the algae need sunlight in order to build their calcareous skeletons. If

an island sinks faster than the corals and algae are able to grow upward to stay in the sunlit zone, then reef growth will cease. If, however, the rate of sinking or sea level rise during an interglacial period is slow enough, the reef will continue to grow upwards toward the light, and seaward toward water-borne nutrients. Since the reef builders (corals and coralline algae) are concentrated on the outer edge of the reef, it grows faster than the inside edge. As the island continues to subside, the water deepens between the sinking shoreline and the fast-growing outer reef edge, forming a lagoon. A reef separated from the shore by a lagoon is called a barrier reef. The best example of a barrier reef in the main islands is at Kāne'ohe Bay, O'ahu. There is also a sub-

Schools of the white jack or "ulua," **Caranx ignobilis,** *are common around the Northwest Hawaiian Islands.*

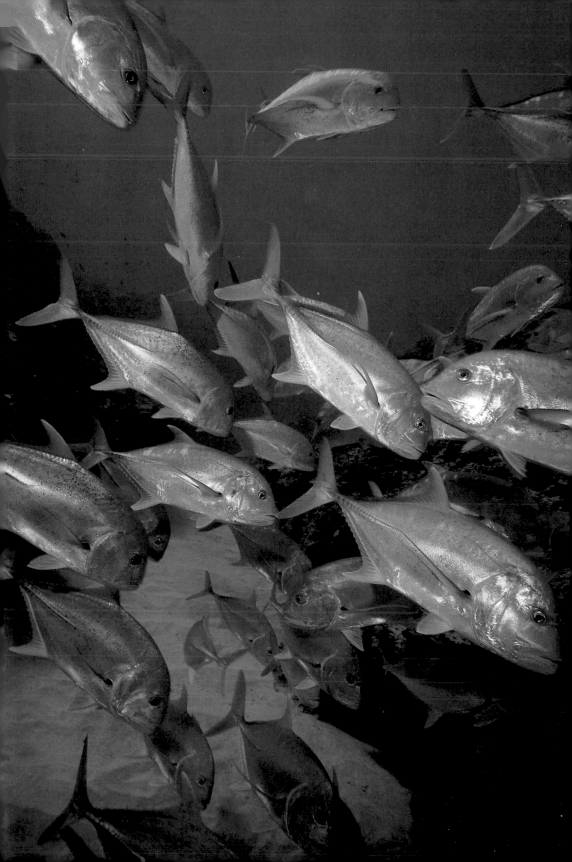

merged barrier reef off the west coast of Kaua'i which is believed to have formed when sea level was lower.

Eventually, the volcanic material sinks completely beneath the surface. If the reef continues its growth upward and outward, forming a complete or partial limestone ring around the submerged island, an atoll is formed. In the northwestern islands atolls are found at Lisianski Island, Pearl and Hermes Reef, Midway and Kure. If reef growth is too slow, then the island becomes a submerged seamount or guyot. The point at which coral growth can no longer keep pace with changes in sea level is called the Darwin Point. In Hawai'i, this occurs at Kure Atoll; islands north of this point are submerged. At Midway the coral deposit is 158 meters thick, capping a long-sunken mass that was once a lofty volcanic island.

Two major breakthroughs in geology during the last 20 years have allowed scientists to determine the ages of the Hawaiian Islands. Age-dating is done by using the constant rates of decay of radioactive substances in the rocks, and has shown conclusively that the islands are older to the northwest. The theory of Plate Tectonics explains why. The earth's crust is divided into many sections, called plates. Hawai'i sits on the large Pacific Plate which underlies most of the Pacific Ocean. The plates float on top of a hot and fluid mantle which is constantly in motion, pushing the plates slowly over the earth's surface. At the site where the island of Hawai'i rests scientists believe there lies, deep within the earth's mantle, a stationary "hotspot." For at least 70 million years this hot-spot has spewed lava onto the sea floor, forming volcanic islands which include the Hawaiian Islands and the Emperor Seamount chain to the north. As the Pacific Plate has moved slowly to the northwest over the hotspot, a steady succession of new volcanoes has been created that is older to the northwest and younger to the southeast. The island of Hawai'i is less than 1 million years old, while Kaua'i is about 5 million and Midway, 27 million. At the very end of the Emperor Seamount chain, the northwesterly movement of the Pacific Plate is forcing seamounts into the Aleutian Trench, where they are reassimilated into the earth's mantle.

*The spotted eagle ray, **Aetobatus narinari**, is found inshore in all tropical and warm temperate seas.*

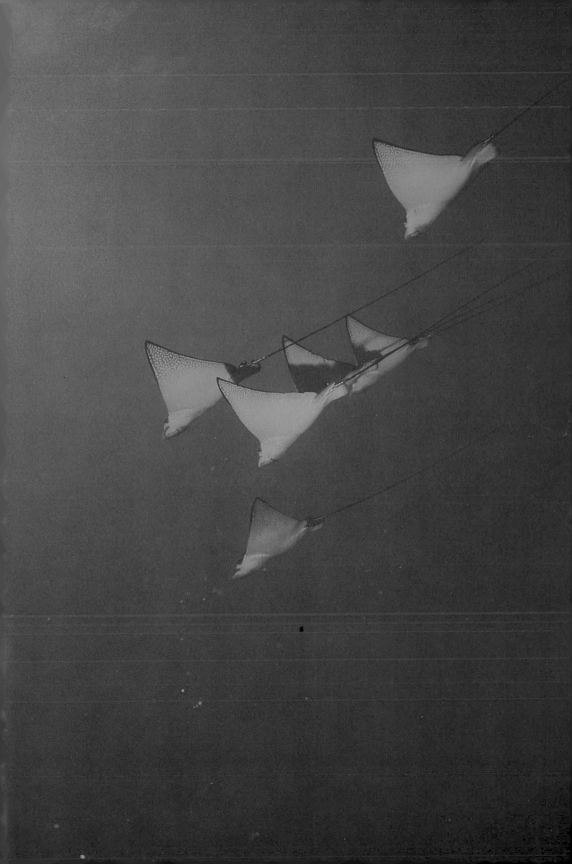

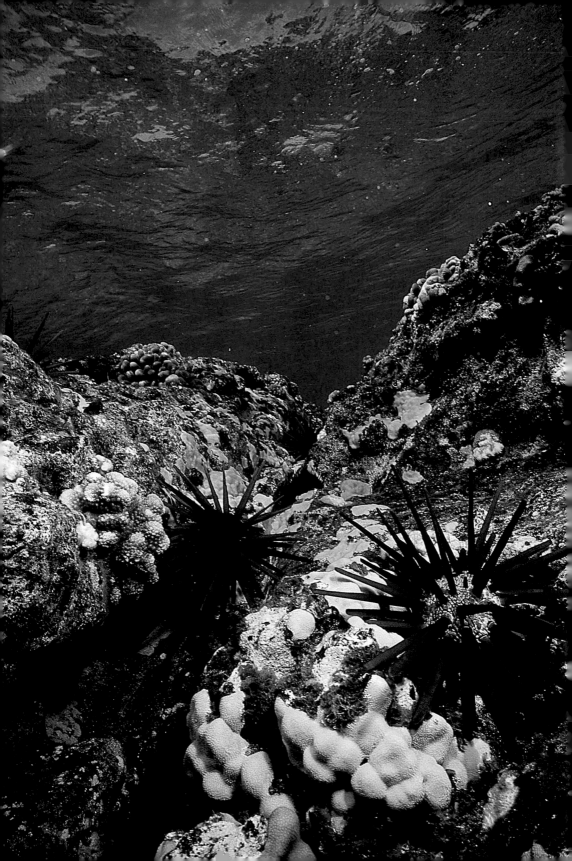

Dispersal of Marine Life

The greatest concentration of species of marine life is found in the waters of the Indonesia–Malay Archipelago of the western Pacific Ocean. This area of shallow, warm water and intense tropical sunlight has offered a large, stable, and diverse habitat area that has nurtured marine life for millions of years. Consequently, it has acted as the center of dispersal for marine life inhabiting the tropical Indian and Pacific Oceans as far west as the coast of Africa and as far east as Hawai'i, the Line Islands, and Easter Island. Marine life in the tropical Atlantic shares a common ancient origin in the Tethys Sea with that of the Indo-West Pacific, but because of land barriers formed when Africa joined with Eurasia approximately 65 million years ago, the two are separate biological entities. During that time the Indonesia-Malay Archipelago appears to have been quite hospitable for the evolution of new species, as it hosts many more kinds of marine life than the Caribbean and tropical Atlantic.

Most dispersal of marine life takes place during the larval stages, when the plants and animals of the sea are tiny, clear,

The combination of slate pencil sea urchins, lobe coral and cauliflower coral is very characteristic of shallow water Hawaiian reefs.

and buoyant. During this time they are carried passively by oceanic currents. How long they survive in this floating, planktonic stage depends on the length of larval life (probably genetically determined), on predation, and on the time it takes to reach a suitable habitat. The longer an animal spends in the planktonic stage, the greater its chance of reaching a suitable habitat, but there is also a greater chance of its dying or being eaten. How far and where it floats is determined by the strength and direction of oceanic currents.

In the tropical Pacific basin, the major currents are the large, westward-flowing North and South Equatorial Currents and the smaller, eastward-flowing Equatorial Countercurrent. In general, these currents do not favor the establishment of marine life from the species-rich western Pacific into the central and eastern Pacific, and there is a definite decrease in the number of species as one travels from west to east. There is also a decrease in species when moving from the equatorial region toward higher latitudes. Still, some species have successfully made the trip to islands as far away as Hawai'i and Easter Island. Close relationships with Japanese species suggest that the

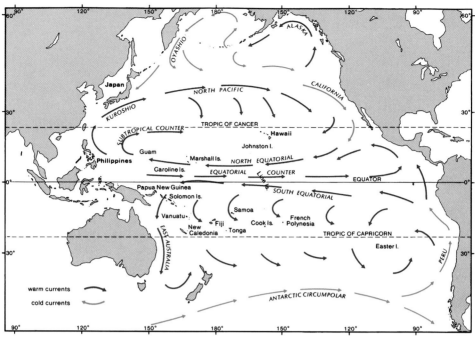

The major ocean currents of the Pacific Ocean do not favor the distribution of marine life from west and east, but islands can help by serving as stepping stones in the dispersal of marine life.

eastward-moving Kuroshio and North Pacific currents have brought some species to Hawai'i. Also, other currents have brought larvae to Hawai'i from the southwest via Johnston Atoll and the Line Islands. Submerged seamounts between the Marshalls and Hawai'i were once above or close to sea level, and could have served as ancient stepping stones.

The role of stepping stones in the dispersal of marine life is very important. In places where islands are clustered together and the distances between them are not great, the marine life may be carried from reef to reef on localized currents and eddies. Once the larvae reach a reef, they can settle down, mature, and reproduce, sending another generation into the sea. Islands and shallow reefs serve as stepping stones in the distribution of marine life

and, by the same token, broad expanses of open ocean act as barriers. For example, the islands of French Polynesia are about the same distance away from the Indonesia-Malay area as are the main islands of Hawai'i, and they lie at a similar latitude on the opposite side of the Equator. However, French Polynesia has a much greater abundance of species. Perhaps the reason lies in the fact that there is a continuous band of islands between Tahiti and Indonesia, but there is a large gap of over 1,000 miles between Hawai'i and the Line, Phoenix, and Marshall Islands, the nearest island groups to the south and west.

It has been estimated that the Philippines have more than 2,000 species of reef and shore fishes, while the Marshalls have about 1,000 species and Hawai'i has 450.

The cauliflower coral is the dominant coral on shallow reefs exposed to heavy waves. Black durgons feed on plankton above the reef.

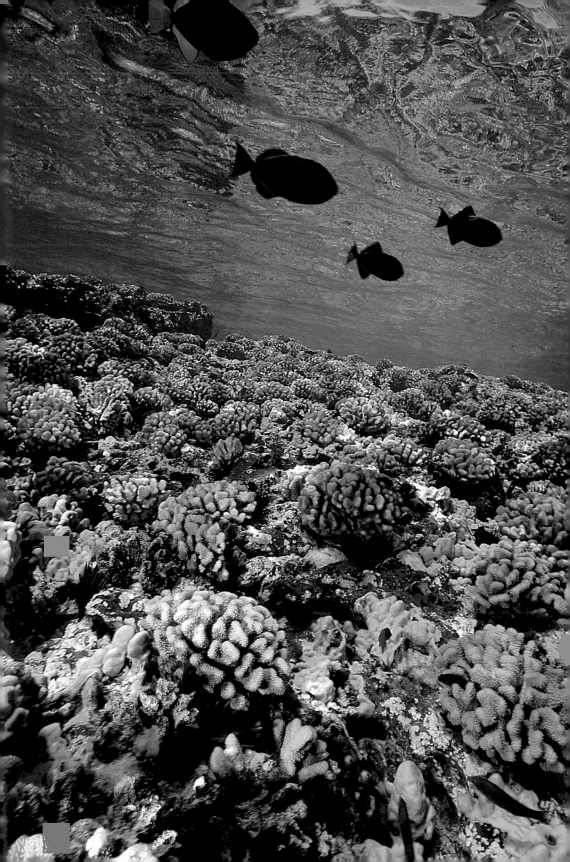

Reasons for this decrease include the great distances animals must travel to Hawai'i from other islands and Hawai'i's less favorable subtropical location with its colder water and lower levels of sunlight.

Besides reducing the number of species to be found in island waters, Hawai'i's isolation has produced a large proportion of endemic species, those found nowhere else in the world. It is estimated that 20-30% of the fishes, 18% of the algae, 20% of the mollusks and 20% of the seastars and brittlestars are endemic. What are the causes of endemism? Quite simply, isolated organisms can only interbreed within their small group. Any changes in the genes of members of a small group will be passed around through interbreeding much more quickly than in a larger one, and eventually there will be enough changes in the genetic composition to make a new species.

A third characteristic of Hawaiian marine life which may result from the area's isolation is that some species relatively uncommon elsewhere in the Pacific are found in great abundance in Hawai'i. Perhaps with fewer overall species there is less competition and predation to limit their populations.

These various effects of isolation have caused the marine life of Hawai'i to have a characteristic makeup. Species which are very common here and not as common in other parts of their range include the slate pencil sea urchin, the collector sea urchin, moray eels, lobe coral, and finger coral. One of the most commonly seen fish, the saddle wrasse, is an endemic, as are the multiband butterflyfish and the fantail filefish. On the other hand, species common elsewhere in the Pacific, such as fishes in the snapper and grouper families and corals of the family Acroporidae, are rare in Hawai'i.

The underwater geology of Hawai'i is also distinctive. Large tracts of gentle slopes of volcanic origin, and dramatic volcanic formations form startling underwater scenes. The unique combination of species superimposed on these volcanic formations gives the Hawaiian marine environment its characteristic look – stark, primitive, and surprising.

The boulder habitat is generally an area of heavy surge where the achilles tang and other surgeonfishes thrive. Only encrusting algae and a little coral grow here.

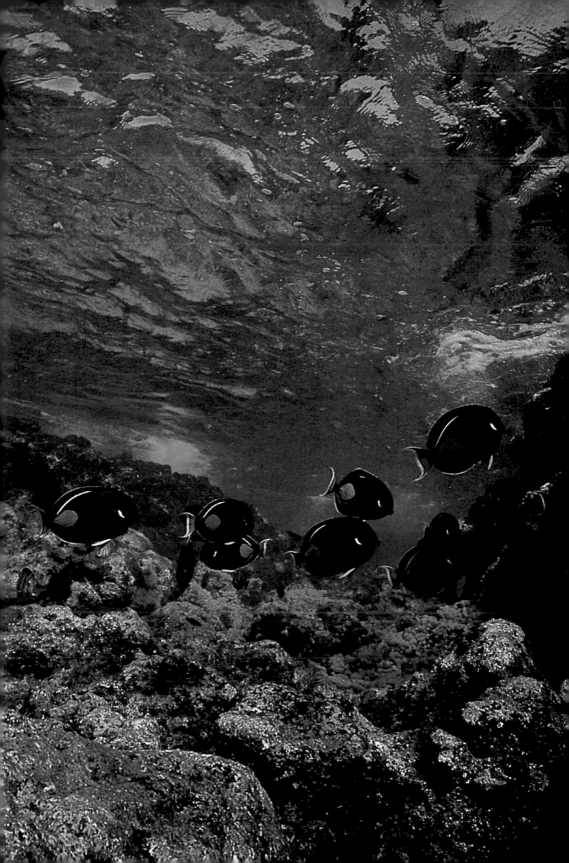

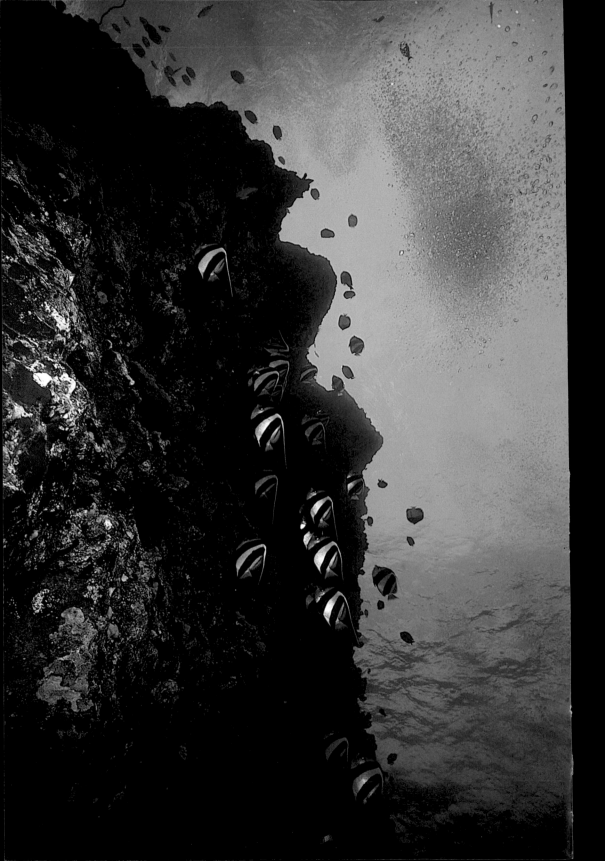

Underwater Habitats

Hawai'i has a variety of underwater habitats. Corals may dominate the scene in calm areas with a hard substrate. Along shorelines exposed to heavy winter surf, the bottom tends to be scoured and strewn with boulders. The volcanic origins of the islands have left behind caves and lava tubes. Erosion of marine deposits has produced great stretches of white sand. The type of bottom, degree of water movement, and depth largely determine the animals and plants that live there. The following list of habitats characterizes in a very general way some of the more distinctive environments encountered by snorkelers and scuba divers.

Coral Reef Habitat

Hawai'i has three basic types of coral reef environments. The first is dominated by the cauliflower coral, *Pocillopora meandrina*. This coral thrives in strong light and high wave energy. It is among the first corals to colonize new lava flows and the dominant coral in shallow areas exposed to heavy wave action. Small crabs, shrimp,

Schools of plankton-feeding pennant butterflyfish feed around steep dropoffs. Small bits of coral, sponges and coralline algae encrust the face of the wall.

and fishes live within its branches. In shallow areas exposed to extreme wave energy, wrasses and surgeonfishes come in to feed. At slightly greater depths, where the water is calmer, more species of fishes and corals are found. Long-snouted bird wrasse feed between the coral branches, while arc-eye hawkfish perch on the heads, scanning for prey.

The second type of coral reef environment is characterized by the lobe coral, *Porites lobata*. This species is found in calmer water than the cauliflower coral. It grows in very shallow depths along semiprotected coasts, or in deeper water along exposed coastlines where it may be mixed with other corals, including cauliflower coral. Many species of fishes and invertebrates find food and shelter here. Fishes which feed on live coral include the teardrop, fourspot, oval, ornate, and multiband butterflyfishes. Small surgeonfishes graze on algae growing on exposed surfaces. Large feeding schools of the convict tang ("manini") may be seen moving over the reef. Hawkfishes sit on outcrops of reef or coral. Parrotfishes use their strong beaks to scrape algae from dead coral surfaces. The black durgon and Hawaiian sergeant feed on plankton above the reef.

Common invertebrates include the slate pencil and collector sea urchins.

The third coral reef habitat is dominated by the branching finger coral, *Porites compressa*. This species is found only in the most protected waters because of its fragile branching growth form. It is normally found growing below the areas that are optimal for cauliflower and lobe coral. It may be found in shallow water in protected bays or on the deeper ocean side of fringing reefs, especially off the leeward coasts of islands. Coral-feeding butterflyfishes are found here, along with larger surgeonfishes, the small goldring surgeonfish ("kole"), juvenile yellow tangs, plankton-feeding damselfishes, the trumpetfish, and forcepsfish. Beds of finger coral provide major nocturnal sheltering areas for many species of fishes.

Boulder Habitat

This habitat is common along exposed coastlines from the shoreline to depths of about 15 meters. It is comprised of large basalt boulders littering the seafloor. The heavy surge and sand in suspension creates scour which makes colonization difficult, and only a few types of encrusting corals and algae are found here. Common fishes found in the surge zone include the lowfin chub or rudderfish, whitebar surgeonfish, and achilles tang. Other surgeonfishes live in the calmer water beneath the surge zone.

Sand Habitat

Extensive areas of flat or gently sloping sand deposits are common along the coastlines of the older islands, from very shallow water to depths exceeding 50 meters. Sandy areas are also found around and between coral reefs and basalt outcroppings, and on terraces in deeper areas below the coral reefs. Most of the invertebrates that live here burrow in the sand, and include mollusks and crustaceans. Many fishes use the sand as a place to feed, seeking shelter elsewhere. These include the yellowstripe and yellowfin goatfishes, the orangeband surgeonfish and larger fishes such as the bonefish and ladyfish. Several wrasses are able to dive into the sand, finding cover there when frightened or sleeping. Some species, such as lizardfishes and flatfishes, are so well camouflaged that they can live on the surface of the sand. A number of fishes use the sand as night feeding areas, as many sand-dwelling invertebrates are active then.

Caves, Caverns, and Lava Tubes

During the day, these types of enclosed habitats provide shelter for nocturnal animals. Almost all of the squirrelfishes, bigeyes, and cardinalfishes can be found hiding in dark areas, as well as lobsters, crabs, and shrimp. Whitetip reef sharks are found resting in caves and under ledges.

Steep Dropoff Habitat

Where the reef drops steeply to great depths, current patterns

Many people are discovering the beauty of the underwater world in Hawai'i through snorkeling and scuba diving. The discerning diver takes time to learn about the animals found there.

may cause upwellings or mixing of plankton-rich water that attracts many types of plankton-feeding creatures. Fishes that feed in this way often occur in large schools or aggregations. Species found here include the milletseed, pyramid, and pennant butterfly-fishes, oval chromis, and sleek uni-cornfish. There may be a variety of hard corals growing on these ba-salt walls interspersed with wire coral, colonial tunicates, sponges, and sea stars.

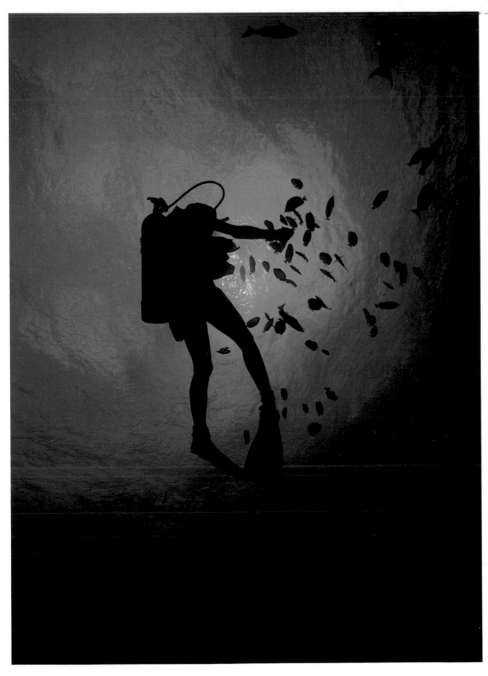

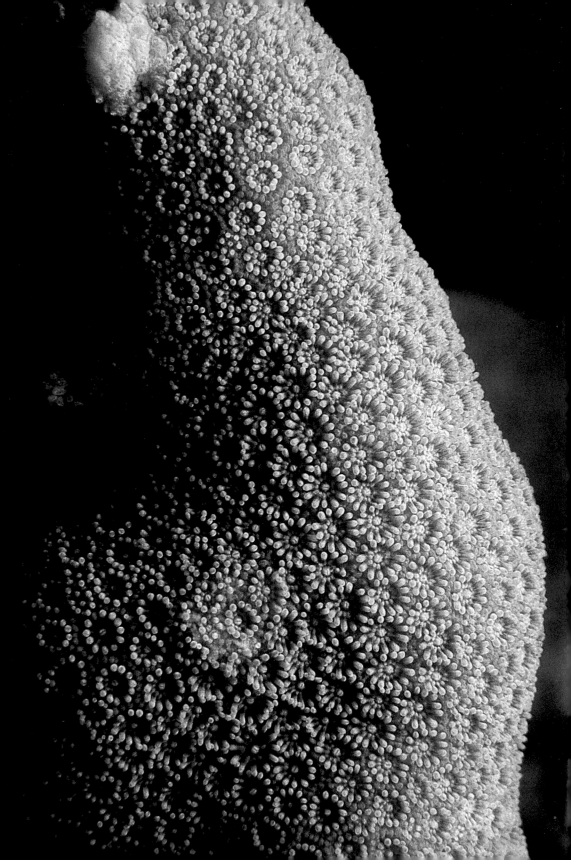

Hawaiian Marine Life

Most of the plants and animals discussed here are commonly encountered by snorkelers and scuba divers, from the surface to 35 meters in depth. The ocean is filled with many colorful and interesting species, each with its own story to tell. All animals are confronted with the dilemma of how to "eat without being eaten," and many have evolved ingenious adaptations in order to survive. By snorkeling and scuba diving, humans can now observe the dynamics of life in this underwater world. Discerning divers are curious about the plants and animals they see and take the time to learn as much as they can about them through reading and personal observation. A good place to start is to learn the names of the plants and animals encountered, since knowledge of the name allows access to the larger body of knowledge that has accumulated about that group or species.

Biologists identify animals by dividing them into major groups called phyla (singular, phylum). A phylum is further subdivided into class, order, family, genus, and species. Members of a phylum share a few major traits; each lower grouping indicates that more traits are shared. Biologists give all plants and animals a scientific name which consists of the genus and species. These two words are always italicized or underlined, and the genus, or first name, is always capitalized. These names are usually Greek or Latin. It is not easy for the nonscientist to pronounce or remember these names, therefore most animals also have common names. The problem with common names is that there may be several different ones for the same animal, or one common name may be used for many species. In Australia, the venomous lionfish is called a butterfly cod and grouper are called trouts. In Hawai'i, some Hawaiian names can be confusing. "Wana" is often used to indicate any sea urchin or, more specifically, one of the venomous species. Scientific names are the same throughout the world and precise identification requires their use.

Finger coral, **Porites compressa.** *Coral is a colony of anemone-like animals called polyps. Each has a central mouth ringed by tentacles and the ability to form the calcium carbonate skeleton. The polyps share tissue and form a thin covering over the skeleton.*

Algae

Marine algae, or seaweeds, are very important to the reef's ecosy-

stem. Like all plants, algae produce oxygen and carbohydrates in the presence of sunlight through the process of photosynthesis. Some algae form symbiotic relationships with animals, others produce calcium carbonate which provides material for sand or aids in the cementing of the reef structure. In Hawai'i, the red coralline (calcareous) algae provide a large percentage of the bulk of the reefs. In the ocean, as on land, plants form the basis of the food chain. Members of the large surgeonfish and parrotfish families rely almost exclusively on algae for food. Among the invertebrates, the sea urchins and many mollusks are herbivores. The people of Hawai'i, too, are fond of seaweed and many kinds of fleshy "limu", eaten cooked or raw provide tasty and nutritious additions to local dishes.

The best places to look for seaweeds are on exposed rocky coastlines, in tidepools, on reef flats, and at the crest on the seaward edge of the fringing reef. Although some seaweeds can grow in sand, most require a hard bottom for attachment. Low tide is the best time to go searching for seaweeds.

Seaweeds are grouped into four divisions: green, blue-green, brown, and red. These divisions are based on the predominant photosynthetic pigments found in each group. Most of them appear the same color as their major pigments; however, the blue-green algae are extremely variable, ranging from gold to black.

Sponges

The sponges are in the phylum Porifera. These are the simplest animals made from more than one cell. Specialized cells, rather than tissues or organs, do the work that keeps the sponge alive. The interior of the sponge is a collection of canals connected to the outside by pores; these canals are lined by hair-like cells, called choanocytes. The choanocytes beat rapidly, creating currents that draw water in through the pores. Collars around the hair cells trap any food brought in, which is then distributed throughout the body by other cells. Water and waste products pass out of the sponge through larger openings called oscula. Sponges have the ability to filter bacteria out of the water, which is one reason they occur in polluted areas. Some sponges living in water with low nutrient levels have evolved a symbiotic relationship with blue-green algae. During photosynthesis the algae form carbohydrates which are then leaked to the sponge.

Sponges may reproduce sexually, by producing eggs and sperm, or asexually by budding or splitting. Their powers of regeneration are remarkable. The skeletal material is made up of tiny rods, called spicules, and a fibrous tissue, called spongin. For defense, sponges produce various toxic chemicals that make them unpalatable to most animals and capable of causing discomfort in humans. In Hawai'i, a few fishes, nudibranchs, and cowries are known to feed on sponges. Different types of animals, such as shrimp or brittlestars, make their homes in and on some of the larger species. Most Hawaiian sponges form rather amorphous clumps on the reef, or under

Pink and green coralline algae encrust the surface of the reef. An angler fish looks like just another piece of algae-encrusted rock.

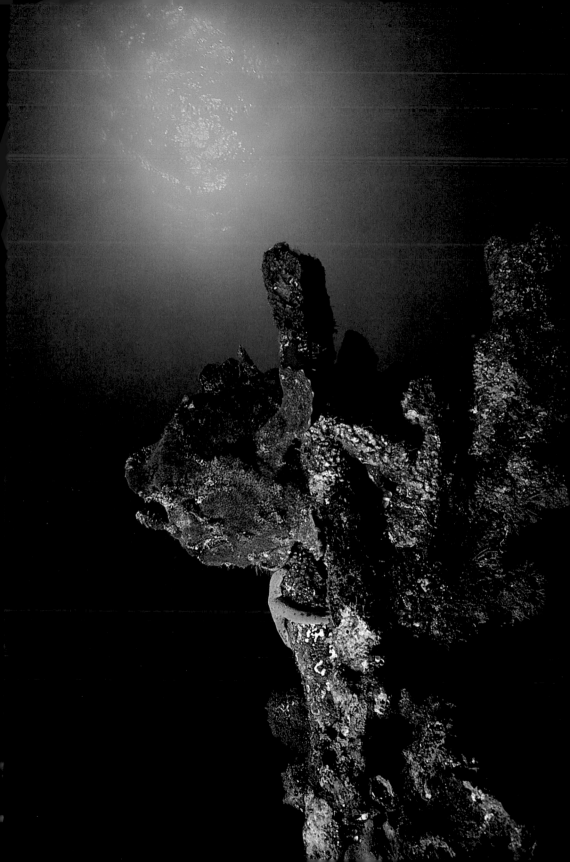

rocks, but some colorful, branching forms can be found in the calm, nutrient-rich waters of Kāne'ohe Bay. Hard, calcareous sponges are found encrusting the walls of submarine caves.

Corals, Sea Anemones, Jellyfish, Hydroids

The phylum Cnidaria is a very large grouping of common marine animals. Cnidarians are more complex than sponges, possessing true organs and a definite form. Most species are radially symmetrical and have simple nervous, muscular, and digestive systems. Although extremely variable in appearance, they all have the same basic body plan. There is a sac-like body with a single opening to the gut, surrounded by tentacles which bear stinging cells (nematocysts) for capturing prey. In some members of this group, such as the Portuguese man-o'-war and hydroids, these stinging cells are potent enough to be hazardous to humans. There are two basic body forms, the polyp and the medusa. The polyp is attached to the bottom while the medusa is free-swimming. Sea anemones and corals are examples of the polyp form, and jellyfishes are examples of the medusa form.

Most corals are colonies of polyps joined together by common tissue. Shallow water reef-building corals secrete skeletons of calcium carbonate (limestone). These are the most visible cnidarians in Hawai'i and provide some framework for the shallow reefs which fringe the shorelines. Reef-building corals have a symbiotic relationship with single-celled algae called zooxanthellae which live within their tissue. When the coral is exposed to sunlight, the zooxanthellae produce nutrients through the process of photosynthesis. Some of these nutrients are used by the coral, while the coral's waste products constitute nutrients which may be used by the zooxanthellae. Corals produce skeletal material at a significantly faster rate when zooxanthellae are present. Because of the zooxanthellae's need for light, reef-building corals flourish in the shallow, sunlit waters of the tropics. Coral polyps also catch prey with their tentacles, like other cnidarians.

Coral Reefs

Coral reefs are limestone structures built mostly of the remains of coralline algae, corals, and other animals. Even though Hawai'i lies at latitudes where the water is too cold for optimum coral growth, the reef corals are still significant contributors to the reef framework and sediments. Reefs are dynamic structures which can either erode or grow depending upon the forces that act on them. These limestone structures are worn down by biological factors, such as the scraping and grinding of marine animals, and by physical factors, such as wave action and the scouring of rocks and sediment. Some reefs in Hawai'i are on the decline due to the effects of soil erosion and sedimentation into offshore waters, sewage dumping, dredging, and shoreline construction.

Red sponges and pink and green coralline algae encrust this reef outcrop. The coralline algae are responsible for much of the reef structure in Hawai'i, as the islands are too far north for vigorous coral growth.

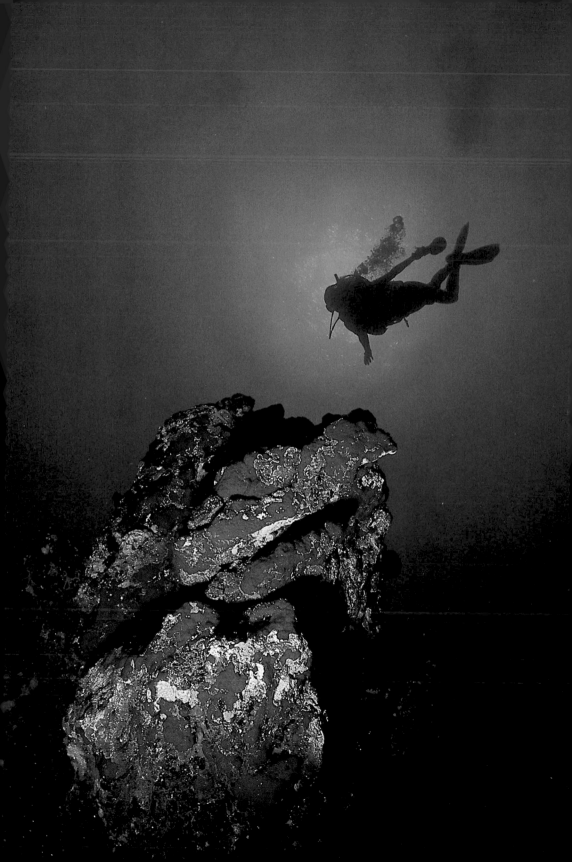

Flatworms

The flatworms of the phylum Platyhelminthes are free-living worms which prey on other small invertebrates. They are usually hidden from view, living under rocks and rubble or in seaweed. Many species are brilliantly colored and are often confused with nudibranchs because both are small, fleshy, and colorful. Flatworms are oval in shape and "thin-like-a-leaf," while nudibranchs are much thicker. Flatworms have a very fluid, gliding method of locomotion which is accomplished by the movement of the many cilia (hairs) on the underside of the animal.

Segmented Worms

The marine segmented worms are

Parrotfishes are responsible for changing much dead coral into sand. Their hard beaks scrape the algae from the surface of dead coral, taking some of the limestone with it.

members of the phylum Annelida and are relatives of the common earthworm. All have the body divided into many segments. Most marine forms are polychaetes, worms which have appendages on each segment. Polychaetes may be free-living or tube dwellers. Many of the tube dwelling species rely on a feathery crown to filter food out of the water. This structure also bears light receptors, so that the crown can be withdrawn if a predator appears. Nerves and muscles that run the length of the body are highly developed, allowing the animal to retreat quickly into its tube. Species often seen by divers include the featherduster worms and the Christmas tree worms. Featherduster worms (family Sabellidae) secrete soft, parchment-like tubes. Christmas tree worms (family Serpulidae) build hard calcareous tubes and have two spiral plumes. They live in heads of the lobe coral. Some tube-dwelling polychaetes such as the spaghetti worm (family Terebellidae) feed by means of long tentacles.

Free-living forms are usually carnivorous, crawling in and around rocks searching for prey. One free-living group, the family Amphinomidae, includes the bristle or fire worms. Contact with the tiny white bristles along the sides of the worm can cause a burning sensation. Polychaete worms are extremely numerous in the marine environment.

Mollusks

The phylum Mollusca includes snails, clams, nudibranchs, and octopuses. Many of the animals in this group have soft bodies protected by one or two shells. When threatened, most are able to pull the soft body completely inside the shell. Most mollusks have a feeding structure called a radula, a ribbon of chitinous teeth which acts like a rasping tongue. Many mollusks are herbivorous, but some, such as the cone shells and octopuses, prey on other animals.

Mollusks with two shells are called bivalves. This group includes the clams, oysters, scallops, and pen shells. Bivalves are bottom-dwellers that draw water in through a siphon, then filter out food and oxygen as they pass over the gills. Water and wastes exit through a second siphon.

Some mollusks have lost the protection of the external shell. These animals include the nudibranchs and sea hares. They have evolved a variety of ways to protect themselves. Some eat toxic sponges, then use the toxins themselves. Others eat stinging cnidarians, recycling the stinging cells for their own defense. Still others are very cryptic, living under rocks or in seaweed and blending with their surroundings.

The octopus and squid have also lost the external shell. These animals have a highly developed nervous system with complex eyes. They have many means of

The tiger cowry grows to its largest size in Hawaiian waters. The orange tube coral lives in areas of strong currents, where it feeds on plankton.

defense, including hiding in crevices, swimming by jet propulsion, blending in with the surroundings, and giving off clouds of ink. They are predators and use quick movements, muscular suction cups, and sharp beaks to subdue prey. Octopuses have a remarkable ability to change both their color and texture.

Shrimp, Lobsters, Crabs

Members of the phylum Arthropoda have a hard outer skeleton, called the exoskeleton, which protects the body like a suit of armor. This shell must be shed periodically to allow for growth, then a new, larger one is secreted. Flexible joints in the legs and body allow movement. Although this phylum includes insects, spiders, centipedes, and millipedes, most of the arthropods the diver sees are in the class Crustacea. This class includes shrimp, lobsters, and crabs in the order Decapoda, which indicates they have five pairs of legs. Many arthropods, such as the insects, have the body divided into three parts: the head, thorax, and abdomen. In the decapods, however, the head and thorax are fused and covered by a hard shell called a carapace. The abdomen is present and may be well developed and used for swimming in the shrimps and lobsters.

Decapods reproduce sexually. The male deposits a packet of sperm on or in the opening to the oviduct of the female, and the eggs are fertilized as they pass from the ovaries to the abdomen, where they attach to appendages called swimmerets. In most decapods the developing embryos are carried by the female until hatching. In crabs, the abdomen is not used in locomotion and has been reduced to a small flap on the underside of the body. It is possible to tell male and female crabs apart by the relative size of the abdomen. In the females it is very wide, in order to protect the developing embryos. The male abdomen is narrow, as it covers only the paired copulatory organs.

Most crustaceans are secretive, hiding in reef crevices and caves, under rocks and rubble, or in the sand, foraging at night.

Bryozoans

The phylum Bryozoa includes colonial animals which build small, hard coverings which may be either low and encrusting or raised into branching, lace- or fan-like structures. The small individual animals are connected to each other through holes in their body walls. During feeding the animal extends a horseshoe-shaped filtering structure called a lophophore. Colonies are found in protected areas of the reef, especially in crevices. They also encrust seaweed, pier pilings, boat bottoms, rocks, and shells.

Sea Stars, Sea Urchins, Sea Cucumbers, Brittlestars

Phylum Echinodermata includes the familiar sea stars, sea urchins, sea cucumbers, and brittlestars. These animals are exclusively marine. All echinoderms have a hydraulic plumbing arrangement called a water-vascular system, which operates hundreds of tube

*The regal slipper lobster, **Arctides regalis**, is the most colorful of the slipper lobsters. It is often found living on the sides and ceilings of caves.*

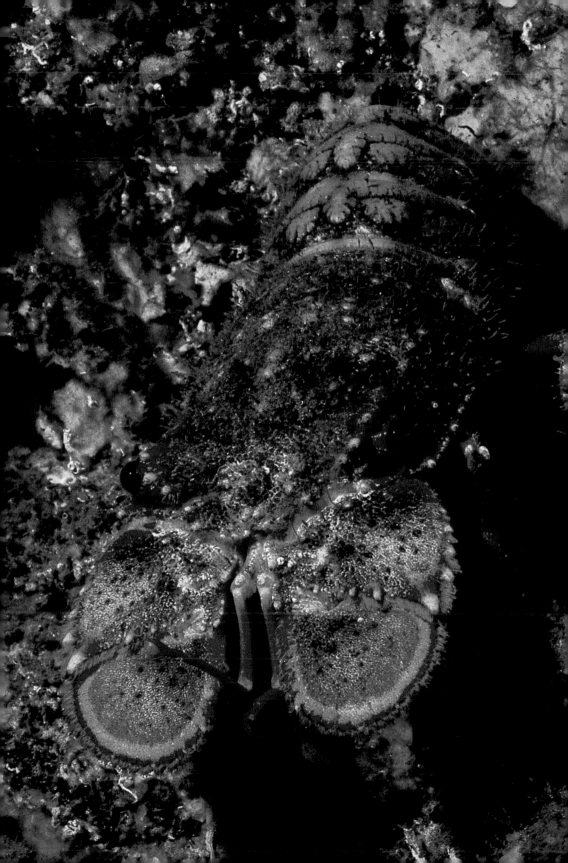

feet. These tube feet are connected to a central water reservoir and are extended or retracted by the force of water flowing through the system. In most echinoderms the tube feet have suction cups at the end that are used for locomotion and attachment. Tube feet without suction cups are used mainly for feeding.

The sea stars have five or more arms or rays. Their delicate tube feet lie in a groove on the underside of each arm. This groove is lined by spines that can cover and protect the tube feet if the sea star is threatened. Most sea stars are carnivorous and feed on all sorts of invertebrates.

Brittlestars superficially resemble sea stars but have many differences. They have a distinct separation between the arms and central disk, whereas the arms of the sea stars grade gradually into the central portion. The arms of a brittlestar are very flexible, while those of the sea stars are rigid. There are no suction cups on the tube feet of brittlestars. The rapid, snake-like movement of the spiny arms is the major means of locomotion. Brittlestars are much more abundant than sea stars, with several living under most rocks at any depth.

Sea urchins are very common in Hawai'i. They are round in shape and covered with spines. Those with long, thin brittle spines are venomous and should be avoided. Common reef species include the slate pencil sea urchin, the collector sea urchin, and the rock-boring sea urchin. Most sea urchins feed on seaweed. The mouth is found in the middle of the underside of the body and bears five tiny white teeth. Sea urchins reproduce by releasing eggs and sperm into the water, where they form planktonic larvae after fertilization.

Sea cucumbers are long, sausage-shaped animals. They creep along on their tube feet, feeding on organic matter from the sea floor with oral tentacles. Sea cucumbers are generally smooth and are often covered with a thin layer of sand. Some species are found under rocks during the day, coming out at night to feed. Several species eject long, sticky white threads from the anus when molested. These Cuverian organs are a defensive mechanism which regenerate.

Tunicates

Tunicates are close relatives of the vertebrates and are placed in the same phylum (Chordata). As adults the sessile tunicates are attached to the bottom and look more like sponges than chordates. However, during their larval stage they have the three chordate characteristics: a dorsal notocord, a dorsal tubular nerve cord, and gill clefts. The body is covered by a tough tunic, giving the animal a smooth, shiny appearance. There are two openings to the body, one to draw in water and food and another to expel water, wastes, sperm, and eggs. They may be either colonial or solitary. Solitary forms, called sea squirts, eject a stream of water when squeezed. Colonial species are most commonly seen in Hawai'i. They may be found on reef surfaces or under rocks.

A closeup view of the tube feet of the crown-of-thorns starfish. Tube feet are used for locomotion and attachment.

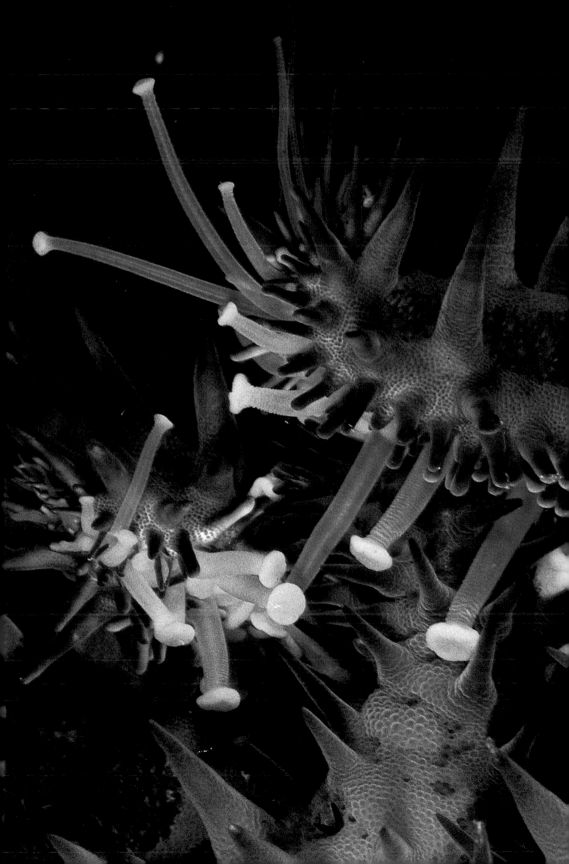

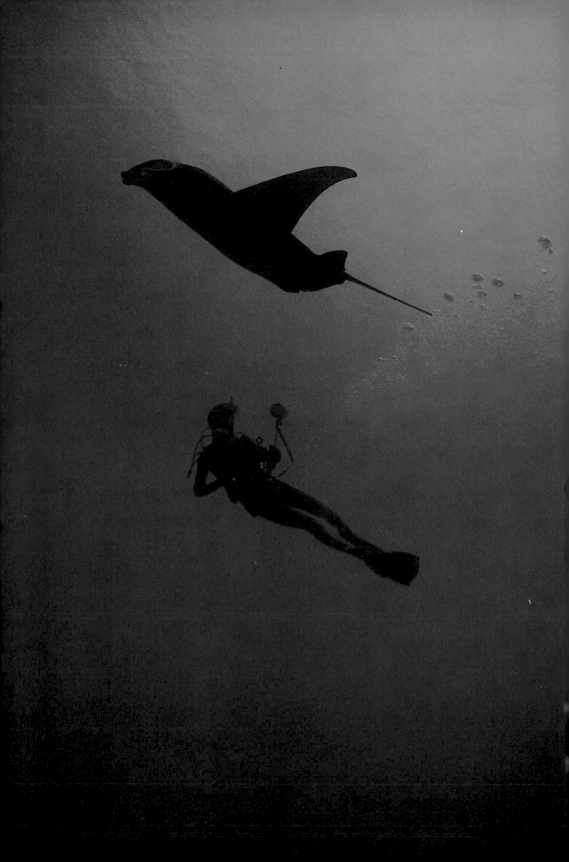

Fishes

Because fishes have a dorsal nerve cord protected by backbones or vertebrae, they are placed in the phylum Chordata, subphylum Vertebrata. They have fins for locomotion and gills for obtaining oxygen from the water. Their body temperature is generally the same as their environment; therefore, they are considered to be "cold-blooded," although some fast- swimming species like the tunas generate body temperatures higher than that of the surrounding water. There are two major classes of fishes: those with skeletons made of cartilage, which includes the sharks and rays, and the bony fishes, which includes most others.

Early fish ancestors are found in fossil deposits 500 million years old. In the course of time they have evolved from heavily armored, clumsy creatures to modern marvels of design and function. Today, there are thousands of species of fishes living in aquatic environments from the tops of mountains to the depths of the oceans. They show modifications of every body part in order to function successfully

The manta ray is a highly modified cartilaginous fish related to the sharks. They are found along the shorelines in shallow water and are harmless to divers.

in a diverse array of ecological niches. Using Hawaiian fishes as examples, the following sections discuss many of these adaptations.

Shape

The shape of a fish is based on the hydrodynamic principle that a long cylindrical shape, broader at the head and more tapered at the tail, moves most efficiently through the water. The pelagic fishes, which spend most of their time swimming, exhibit this form. These include the tunas, jacks, and marlins. While this shape is designed for speed, it does not allow great maneuverability. The most agile of fishes are the disc-shaped species, with their laterally compressed, short, but deep bodies. These include the butterflyfishes, angelfishes, and surgeonfishes. In these families the pectoral fins are placed high on the sides of the body, and when they are extended, the fish can pivot about them. With a short, deep body shape, the center of gravity is near the pectorals, and all parts of the trunk are equally resistant to lateral movement. This combination of shape and fin placement allows rapid turns and quick stops in a shorter distance, appropriate

for species that live and feed near the bottom and dart into crevices for protection.

There are some families of fishes that spend most of their time lying on the bottom, whether on sand, rocks, or coral heads. These families include the lizardfishes, hawkfishes, scorpionfishes, and anglerfishes. Members of these families have a body shape which is broader on the bottom than the top, providing a wide, stable platform.

Some families have a long, thin body shape. These include the eels, needlefishes, halfbeaks, cornetfishes, and trumpetfishes. The eel's shape allows it maximum flexibility for living within the crevices of the reef. The needlefishes and halfbeaks live at the surface of the water, while the trumpetfish and cornet fish are found near the reef. All prey on small fishes. Their thin shapes, combined with colors which blend in with the environment, make them difficult to see.

Fins

Fishes also show adaptations in fin shape and arrangement. Some fins are single and median (lying along the mid-line of the body). These include the dorsal, along the back, the anal, lying along the posterior end of the belly, and the caudal or tail fin. The paired fins include the pectorals and pelvics. The pectoral fins are either above or in front of the pelvic fins.

The fossil record shows that the pectoral fins originally were found low on the body, behind the gill openings, while the pelvic fins were midway between the pectorals and the tail. Early fishes had no swim bladder to aid in buoyancy, and these fins were used for continuous swimming. After the evolution of the swim bladder, fishes could regulate their buoyancy, freeing the pectoral and pelvic fins for other uses. Most modern fishes now have the pectorals placed high on the side of the body where they are used primarily for braking and turning, although some fishes such as wrasses and parrotfishes also use them for swimming. Most fishes have short, wide pectoral fins, but there are some notable exceptions. In the jacks, the pectorals are long and thin, and are used only for turning. In the flying gurnards and flying fishes, they are large and wing-like. In the bottom-dwelling scorpionfishes and anglerfishes, they are thickened and used as props or feet. Sharks have very large pectoral fins which provide lift, since these fish lack swim bladders.

The tail fin also shows a variety of adaptations. The fast swimming fishes, such as the tunas, sailfishes, marlins, and swordfishes, have a very rigid, tall, thin tail. This shape reduces drag at high speeds and is efficient for continuous swimming. It is poorly adapted for swimming at slow speeds and maneuvering. Sharks have a heterocercal tail, with the top lobe longer than the bottom one. This asymmetrical tail provides lift along with forward thrust. Most reef fishes have rounded tails that are soft and flexible for quick acceleration and maneuverability. Goatfishes and squirrelfishes have soft, forked tails producing less drag, but still

*The chub or rudderfish family includes 4 species in Hawai'i. The lowfin chub, **Kyphosus vaigiensis**, "enenue" is the most common. This fish normally crops algae from the reef but is common and occasionally aggressive in areas where divers feed fish. They are usually gray, but occasionally a yellow individual is seen Size: 25–35 cm.*

flexible for maneuvering. Eels have no tail fin at all, swimming by undulating their flexible bodies.

The dorsal and anal fins also show a variety of adaptations. Dorsal fins of many species have rigid spines in the front and soft, branched rays in the back. These may be arranged in a single, continuous fin, as in the butterfly-fishes and surgeonfishes, or separate, as in the squirrelfishes and goatfishes. Many reef fishes raise and lower the spiny portion of the dorsal fin to communicate various "moods." Fast swimming fishes, like tuna, have a slot for the dorsal fin, allowing it to be tucked away to reduce drag. Some families of fishes use the dorsal and anal fins when swimming, such as triggerfishes, filefishes, trunkfishes, puffers, porcupinefishes, and trumpetfishes.

Mouths and teeth

Biologists believe that many different kinds of fishes can live together on a coral reef because they eat different things. It is often possible to tell what a fish eats by looking at the mouth and teeth, as these parts have evolved to allow different species to specialize in the types of food they eat. Carnivorous species usually have large mouths with many sharp teeth. This type includes eels, groupers, sharks, jacks, and barracuda. Algae feeders, such as surgeonfishes, have small mouths and tiny, comblike teeth for scraping fine seaweed off reef surfaces. Daytime plankton feeders, including members of both the butterflyfish and damselfish families, have tiny upturned mouths. Nighttime plankton feeders, such as the squirrelfishes and the glass-eye, have larger upturned mouths,

as their prey includes larger crustacean larvae. The bird wrasse, moorish idol, and forcepsfish have elongated snouts with terminal teeth for grabbing prey in crevices. Coral feeders, such as the multi-band butterflyfish, have tiny mouths and teeth for grasping individual polyps. Many fishes eat hard-shelled invertebrates. These species, such as the wrasses and emperors ("mu") have strong canine teeth in the front for grasping prey, and pharyngeal (throat) teeth or molars for crushing them. Perhaps the parrotfishes have the best-known teeth of all. In this family many teeth are fused to form a hard beak which is used to scrape off the fine algae that grows on and in the surface of dead coral. During this scraping much of the hard coral skeleton is ingested and is further crushed by the pharyngeal teeth. The organic material is digested, and large quantities of fine sand are then excreted.

Colors

As any diver or aquarium enthusiast knows, the colors of fishes in shallow, tropical waters are astounding: vibrant yellows, fluorescent blues, and shimmering silvers bring a bright gaiety to the underwater scene. Other species blend in with their environment, choosing more conservative blacks, browns, and grays. Color can reveal a lot about the lifestyle of a species. Fishes that spend their time in open water, such as tunas, marlins, mahimahi, sharks, half-beaks, and needlefishes, have a coloration called "counter shading," being dark on the back and

The moluccan anglerfish, **Antennarius moluccensis,** *is a large species reaching 30 cm. in length. It has a very blotchy appearance. It is easy to see how this fish can fool its prey!*

light on the belly. When viewed from above, the dark back blends in with the dark blue water or ocean bottom, while when viewed from below, the light belly blends in with the bright, sunlit water.

The butterflyfishes are well known for their bright yellow color and bold patterns. Aren't they easy targets for predators? Perhaps not. Most butterflyfishes have a dark stripe that conceals the eye and a black spot elsewhere on the body that may serve as a false eye spot (ocelli). This may confuse a predator as to which way the butterflyfish is headed, giving it enough time to slip into a reef crevice. Bold patterns also help fish distinguish members of their own species. However, males and females of the parrotfish and wrasse families are usually of different colors. In these families the females are also known to change sex and become males. Perhaps some way to distinguish an individual's current sex is helpful!

The tiny cleaner wrasse uses bright colors to advertise its services. The yellow head and purple tail stand out like a neon sign, inviting fish into its territory for removal of parasites and dead or diseased tissues. This fish is not eaten by larger, predatory fishes, which utilize these services.

Color can also be used to camouflage. The sand-colored manyray flatfish is virtually invisible when lying motionless on the sand. It can only be seen when it moves. Scorpionfishes rest on the bottom, blending in with surrounding algae-encrusted rocks. The devil scorpionfish is often found in shallow water; therefore it poses a threat to barefoot waders in rocky areas.

Many deep-bodied reef fishes are marked with vertical or slanted bars which break up their outline against the crazy-quilt pattern of the reef. This is called disruptive coloration. The convict tang, Hawaiian sergeant, moorish idol, and many butterflyfishes, show this type of pattern.

Some fishes are able to change their color. In the case of the trumpetfish, this is done in order to blend in with the environment. Trumpetfish are ambush predators and must sneak up on their prey without being detected. They may be dark when hovering under ledges, very pale when swimming with a school of convict tangs, bright yellow when living in an area with yellow tangs, or just plain gray when swimming about the reef. Spots near the tail make it difficult to detect which end has the eye.

Fish can also change color to express themselves. The orange-spine unicornfish can flash a bright yellow area on the forehead when chasing another fish away, while the cornetfish can take on a banded pattern when threatened. At dusk the pyramid butterflyfish may defend an area on the reef by darkening the white area on its side and then flashing a white spot in the center.

Scales and toxins

Other adaptations for success on the reef include the evolution of specialized scales and toxins for protection. The spotted trunkfish has a rigid body formed by bony scales that fit together like tiles. The scales of the porcupinefishes have evolved into large spines. When threatened, the body is inflated with air or water and the spines become erect. Both of these slow-moving fishes are also poisonous. The trunkfish secretes a toxin into the water when dis-

turbed, while parts of the porcupinefishes are poisonous to eat. Scorpionfishes inject venom by means of hollow spines in the fins.

Behavior

Coloration is combined with specialized behavior patterns to provide the utmost protection. Camouflaged fishes are more successful when lying motionless. When brightly colored fishes such as pyramid butterflyfish and pennantfish are feeding in midwater they form a school, as single individuals would be picked off easily by predators. Brightly colored butterflyfishes and surgeonfishes are much safer by the reef, where they can hide, than over the sand or up in the water.

Other body parts that have been modified for different purposes in the fishes include the swim bladder, the lateral line, and the digestive and reproductive systems. Each species of fish is the product of millions of years of evolutionary fine-tuning and any mistakes are another's dinner.

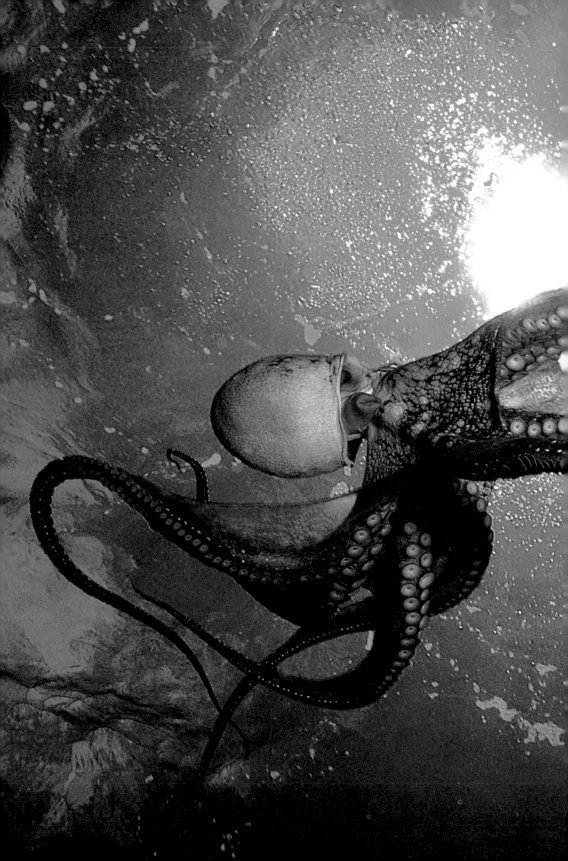

Species

1▲

Algae

Algae, or seaweeds, are plants that are an important part of the marine environment, providing food for sea life and helping to create the rigid reef structure. Algae are divided into four groups: green, red, brown, and blue-green.

1 - The sea lettuce, **Ulva fasciata** is a very common green alga found in the intertidal zone. It is bright grass-green in color and grows in flat, twisted strips.

2 - The bubble alga, **Dictyosphaeria sp.**, is a green seaweed made up of tiny, round cells. It can be found in tidepools and on shallow reefs.

3 - Many types of algae are able to deposit calcium-carbonate, and are called coralline algae. These algae are important reef builders in Hawai'i. **Porolithon gardineri** is a red coralline algae that forms pink or purplish crusts or clumps. It thrives in heavy surf and strong currents.

4 - In Hawai'i, a light-colored veneer of coralline algae is found on lava rocks exposed to heavy surf. Photo by A. Fielding.

2▲ 3▼

4▶

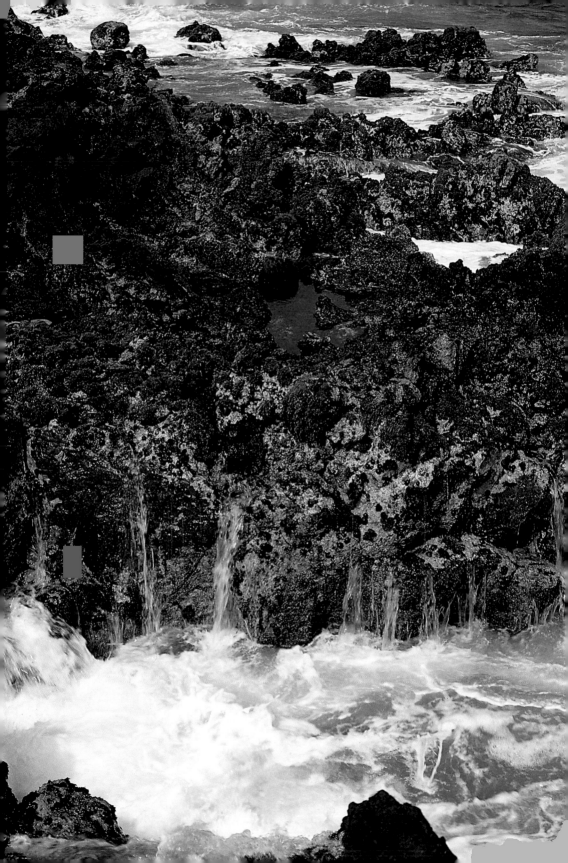

Sponges

5 - *Sponges are very simple animals that feed by creating currents which move plankton-laden water in and out of the body through pores. The large holes on this orange encrusting sponge are for the outflow of wastes.*

6 - *This small orange sponge shows the delicate network of tiny incurrent pores, through which food and water enter the sponge, along with two larger excurrent pores.*

7 - *Contact should be avoided with this branching orange sponge. Most sponges contain irritating toxic substances and should not be touched; however, a few animals are able to tolerate them as food. The skeletal matrix supporting most sponges is made of tiny rods, called spicules, and a fibrous material, called spongin.*

5▲ 6▼ 7▶

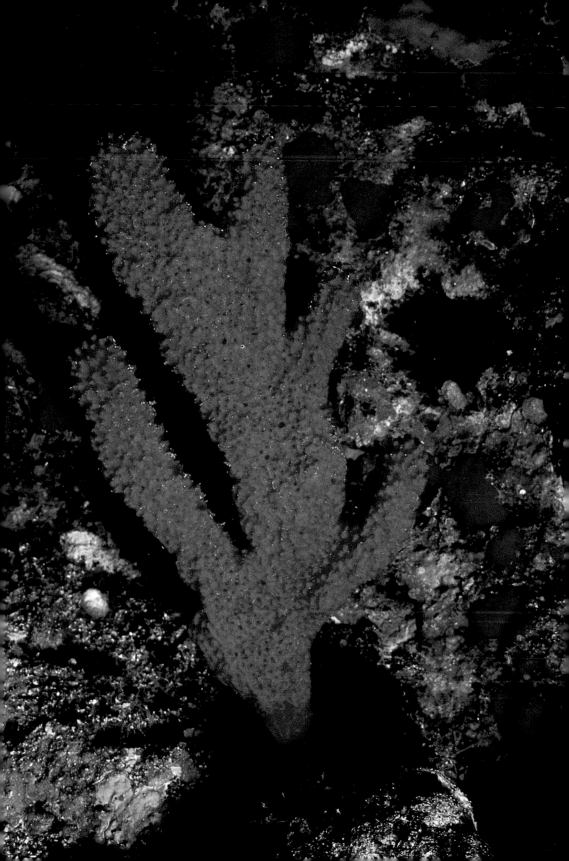

Corals

A coral is a colony of many tiny animals resembling sea anemones. Many coral colonies form limestone skeletons. The most common limestone-secreting corals are the reef-builders, a group having a symbiotic relationship with tiny algal cells residing in the living coral tissue. These algae aid in supplying nutrients to the coral in the presence of sunlight.

8 - This close-up view of the cauliflower coral shows the tiny calices, or cups formed by each member of the colony, arranged around the small knobs characteristic of the genus **Pocillopora.**

9 - The cauliflower coral, **Pocillopora meandrina**, is the favored resting spot for the arc-eye hawk-fish. These coral heads are home to several species of crabs, fish, and snails, and should not be taken from the reef. This is the most important colonizing species on new lava flows. It is commonly found in shallow areas exposed to wave action. Photo by J. Maragos.

10 - The antler coral, **Pocillopora eydouxi**, is quite large with thick, pipe-like branches. It grows in water deeper than 6 meters.

8▲ 9▼

10►

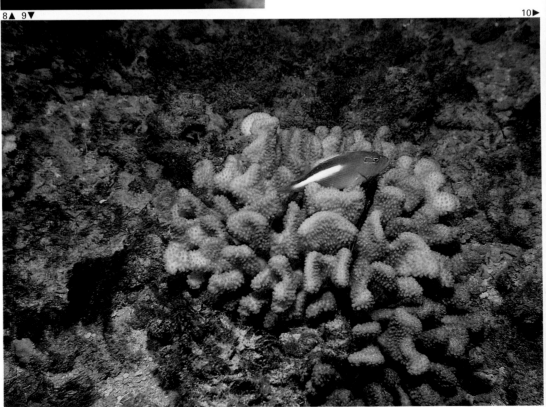

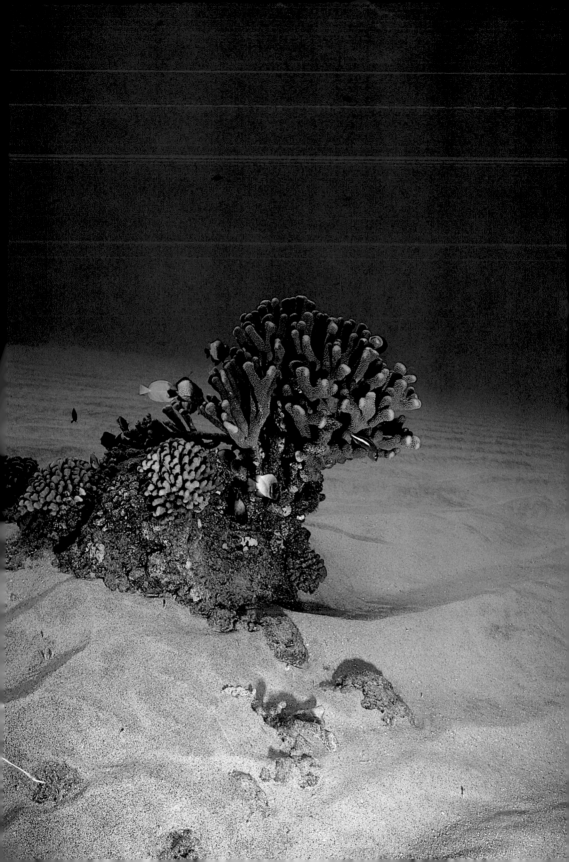

11 - *The finger coral,* **Porites compressa**, *is the second most common coral in Hawaii. It prefers calm water, and it forms large beds in wave-protected bays and on deeper reef slopes on the leeward sides of the islands. In such environments it has a rapid growth rate and can crowd out other corals.*

12 - Porites (Synaraea) rus *has an unusual growth form. It may form columns or brackets. The columns grow on the exposed reef top while the brackets, seen here, are found in more protected or shaded areas.*

13 - *Large black cracks are often seen on the surface of the lobe coral,* **Porites lobata***. These are burrows formed by the snapping shrimp* **Alpheus deuteropus.**

14 - *The lobe coral,* **Porites lobata***, is the most common coral in Hawai'i. It may be seen as an encrusting form on the reef surface, or in large mounds. It prefers wave exposed reefs between 2 and 15 meters in depth. A goldring surgeonfish ('kole') swims over the coral.*

11▲

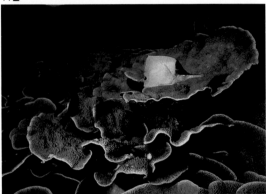

12▲ 13▼

14►

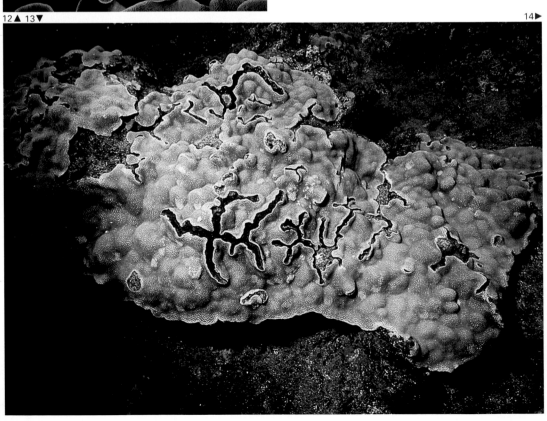

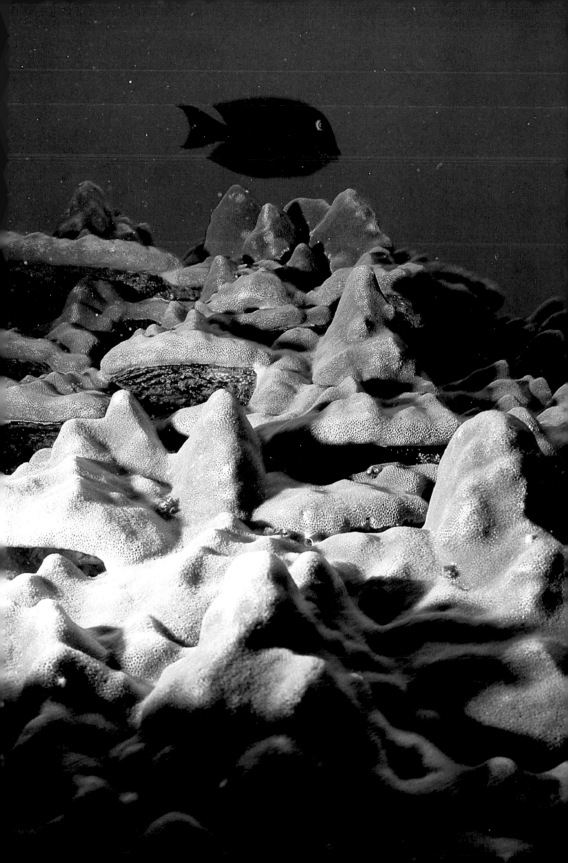

15▲

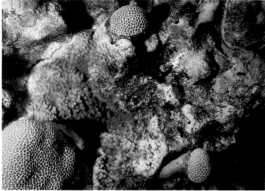

16▲ 17▼

15 - **Montipora verrucosa** *is a common species which grows between the surface and 45 meters. The color is generally tan with a white margin. The bracket form shown here is only one of the many shapes this species can take. Photo by J. Maragos.*

16 - **Montipora patula** *is an encrusting coral, with the rice-like texture characteristic of* **Montipora** *corals. It is seen here with small clumps of lobe coral. This species is common below 3 meters. Photo by J. Maragos.*

17 - *The vivid blue of* **Montipora flabellata** *makes it easy to identify. It is found in encrusting patches in shallow locations with heavy wave action. It is especially abundant on the left side of Honolua Bay, Maui, where this photo was taken. Photo by J. Maragos.*

18 - *The lobe coral,* **Porites lobata** *is seen in the background with the blue-colored* **Montipora flabellata** *in the foreground. Photo by A. Fielding.*

18▶

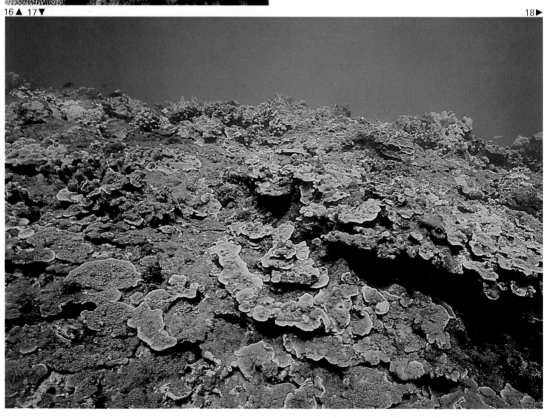

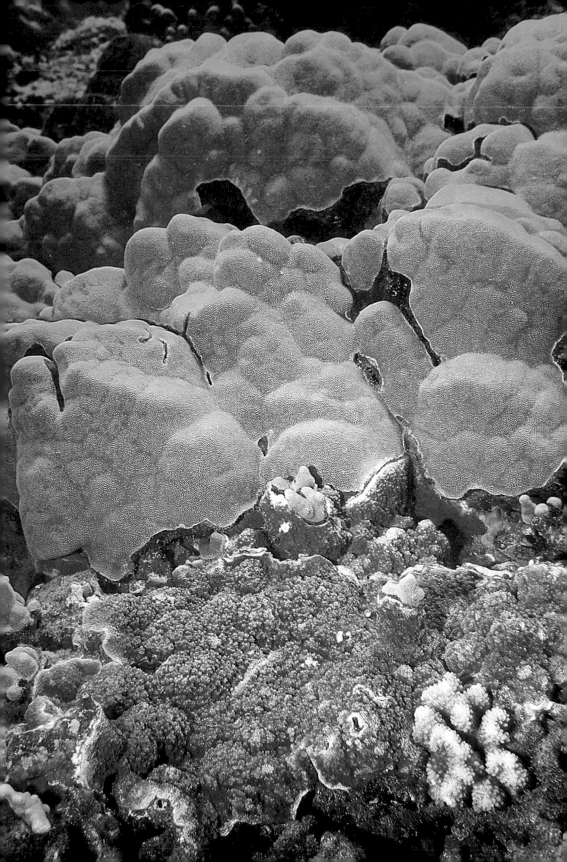

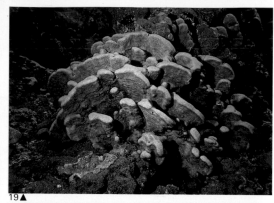

19▲

20▲ 21▼

19 - *Large colonies of* **Pavona duerdeni** *have a characteristic growth form of flattened ridges. The calices have a star shape and form a symmetrical pattern. This species is found in environments exposed to wave action.*

20 - **Pavona varians** *is a common coral occurring from the surface to at least 25 meters. It is normally brown in color and is frequently seen growing at the bases of finger coral. The narrow, curling ridges are characteristic of this species.*

21 - **Cyphastrea ocellina** *is a common, shallow-water species forming small reddish brown encrustations or clumps. The calices are round with raised walls. Open spaces between the calices have small points. Photo by J. Maragos.*

22 - **Leptastrea purpurea** *is an encrusting form found in shallow wave-exposed environments as well as in deeper areas. It is often confused with* **C. ocellina** *, but has larger, angular, funnel-like calices with no open areas between. Photo by J. Maragos.*

22▶

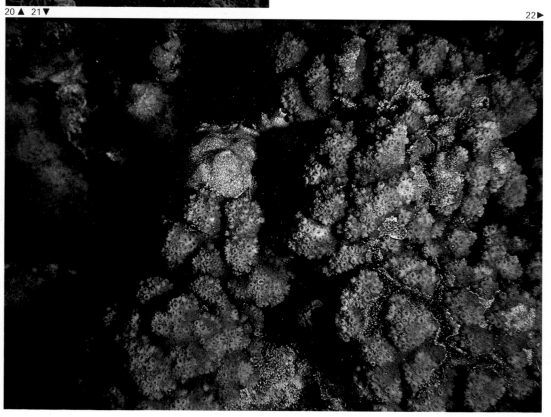

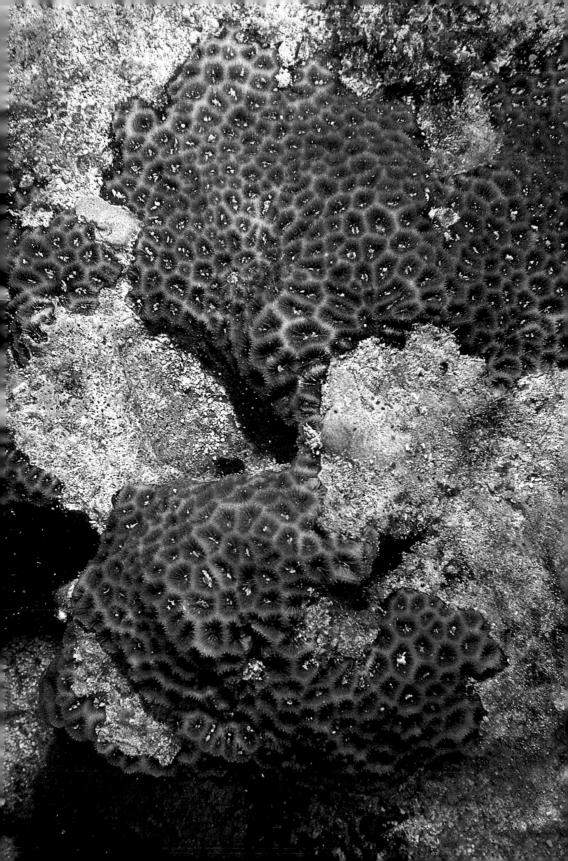

23 ▲

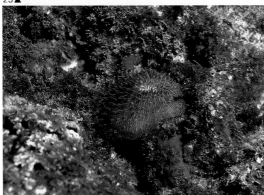

24 ▲ 25 ▼

23 - *The orange tube coral,* **Tubastraea coccinea,** *lacks the symbiotic algae found in most other corals and must rely entirely on plankton for food. It forms colonies from the surface to depths of at least 30 meters on steep walls, ledges, and the ceilings of caves.*

24 - *The mushroom coral,* **Fungia scutaria***, is a solitary, unattached coral. Immature forms are attached to the bottom, then break off when they are about an inch across. The small feeding tentacles and the white-colored mouth are seen here. Individuals grow up to 18 cm. in length.*

25 - *The wire coral,* **Cirrhipathes anguina***, is a black coral. The living tissue of this species is green. It grows at depths between 10 and 35 meters. Divers who look closely may catch glimpses of the tiny fish and shrimp which are adapted to live on this coral.*

26 - *Black corals, also known as antipatharians, are not reef building corals and do not depend on light. They are found in deep or dark areas of the reef. They form a skeleton which is used in jewelry making.* **Antipatharia dichotoma** *is the black coral most often seen by sport divers, occurring between 25 and 75 meters. The living tissue covering the skeleton is reddish in color.*

26 ▶

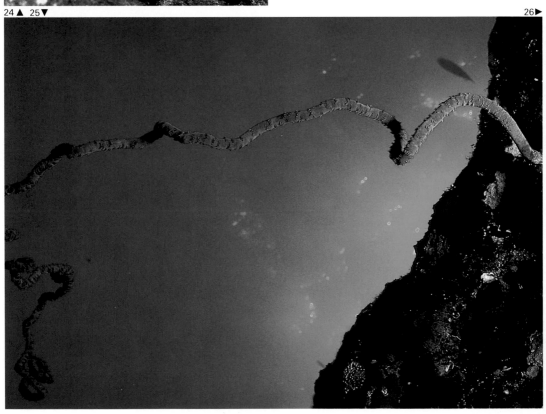

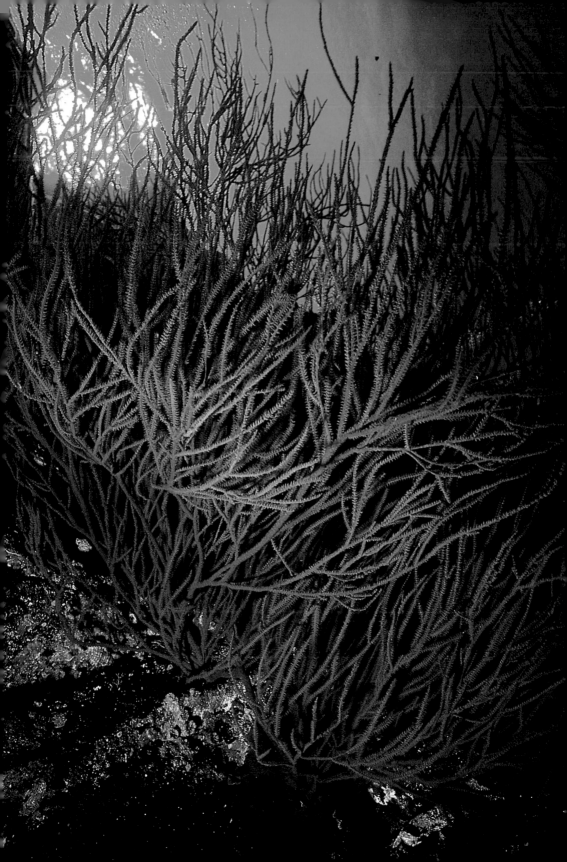

27▲

Coral relatives

27, 28 - *Hydroids sting. These feathery colonies support thousands of carnivorous polyps with stinging cells for gathering prey. The more commonly seen species have some white on them. Hydroids range in size from a few millimeters to about 15 cm.*

29 - *This dark groove in the lobe coral,* **Porites lobata***, is formed by a snapping shrimp. The edges of the burrow are lined with a tiny, white-tipped hydroid.*

30 - *The bluish Portuguese man-o'-war.* **Physalia physalis***, is related to the hydroids, and its long tentacles pack a powerful sting. The air bladder keeps this colonial animal floating at the surface. Although they usually live in the open ocean, storms can bring them in to Hawai'i's beaches. Stay out of the water if they are seen washed up on the beach. The bubble is 3-5 cm in length.*

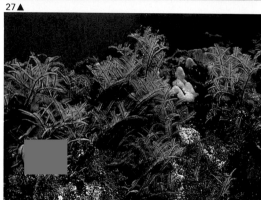

28▲ 29▼

30▶

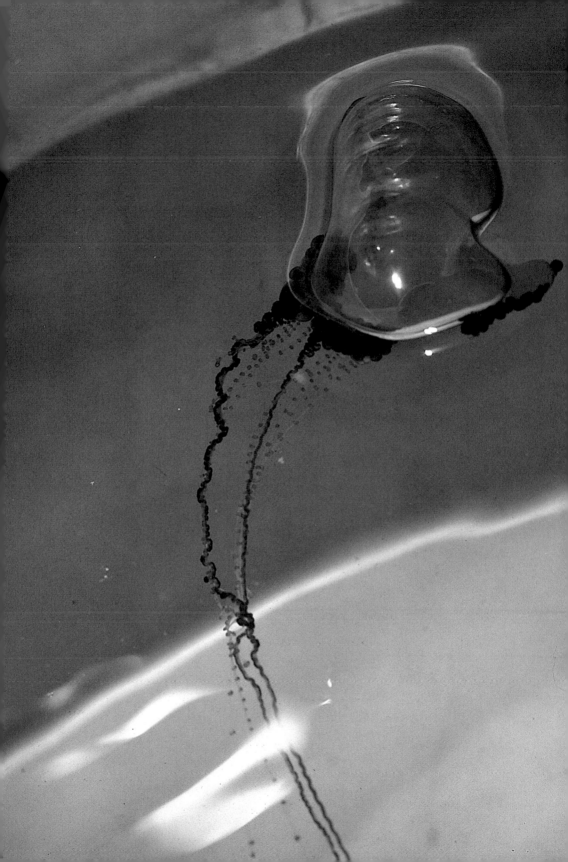

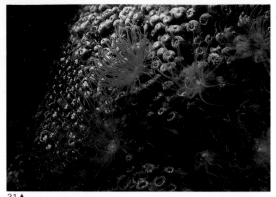

31 - Long tentacled sea anemones, **Aiptasia pulchella**, are interspersed here among a colony of zoanthids. Zoanthids are closely related to sea anemones. Both have an upright column and a central gut surrounded by feeding tentacles. In Hawai'i, sea anemones and zoanthids are small, usually less than 6 cm in height.

32 - The feeding tentacles of zoanthids are much shorter than those of sea anemones. Zoanthids are found in colonies in tidepools and on shallow reefs. One type of zoanthid is toxic to humans, so all should be avoided.

33 - In this reef scene, large mats of the zoanthid **Palythoa tuberculosa** cover the reef with a gray carpet. It is also common on shallow reefs exposed to heavy wave action.

34 - Jellyfishes have a large fleshy bell that slowly expands and contracts, propelling the animal along. Carnivorous species have long tentacles with many stinging cells, and should be avoided. Dangerous jellyfish, however, are not common in Hawai'i.

31▲

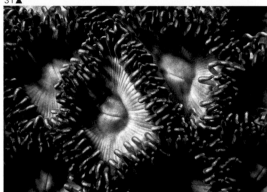

32 ▲ 33▼

34▶

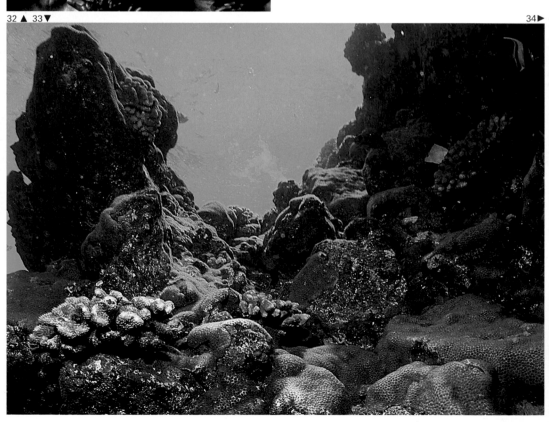

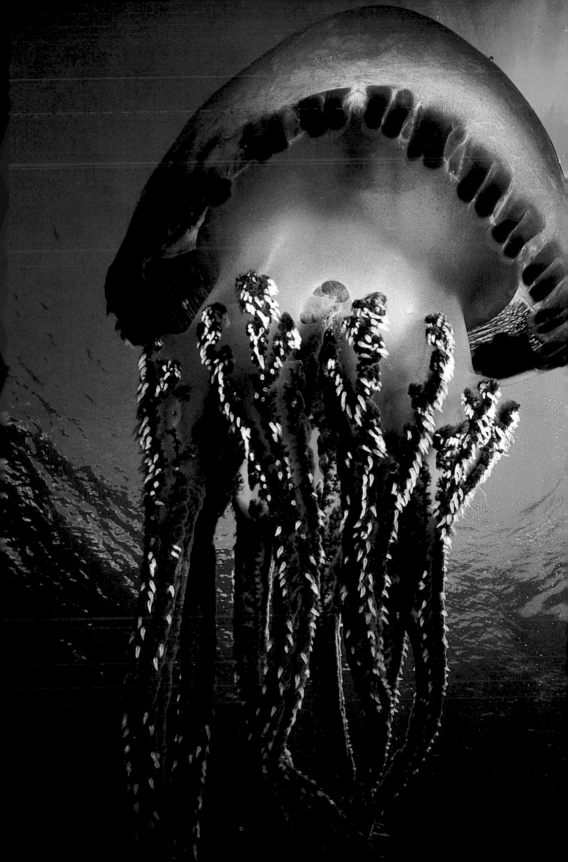

Octocorals

The octocorals are a group of cnidarians that have polyps with eight feathery tentacles. This is a common group in most tropical areas, but in Hawai'i, there are just a few species.

35 - The gorgonian **Acabaria bicolor** is less than 2 cm. in height. The color varies from white to orange, red, or pink. They are always found in protective crevices in the reef at depths ranging from 2 – 35 meters. Gorgonians have flexible skeletons and include the seafans so prevalent in other tropical areas.

36 - **Anthelia edmondsoni** is an octocoral that forms a soft lavender lawn in tidepools and to depths of at least 20 meters. Individuals are only about 2 mm. high, but the colonies are conspicuous in shallow areas because of the color. Photo by J.Maragos.

37 - The snowflake coral, **Telesto riisei**, forms upright stalks with white polyps. It is growing here with some black coral. It can be found at depths ranging from 5 to 50 meters in areas of strong currents.

38 - **Sinularia** forms large colonies that superficially resemble stony corals, but are flexible to the touch. The individual polyps are usually withdrawn. Two species have been reported from Hawai'i.

35 ▲

36 ▲ 37 ▼

38 ▶

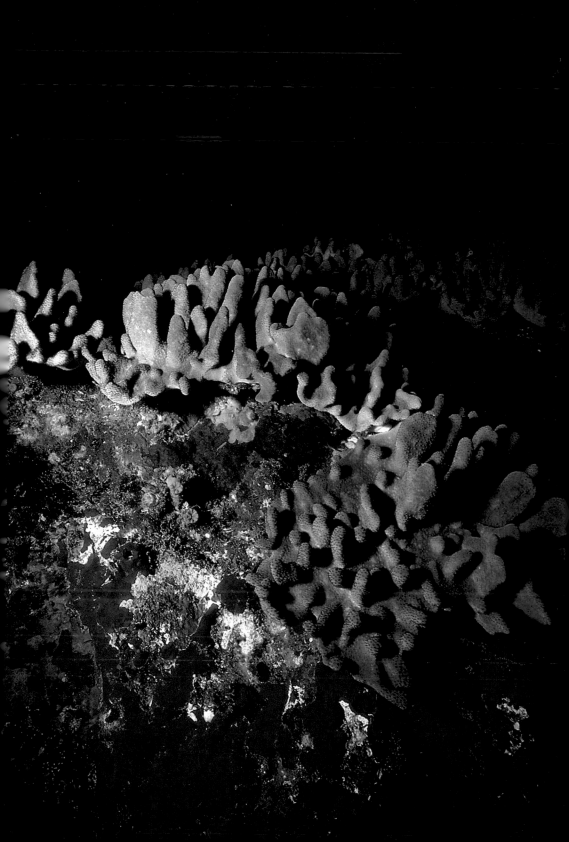

39▲

Marine worms

39, 40 - *The acorn worms are in the phylum Hemichordata. Most acorn worms construct mucus-lined burrows in sand or mud. A new species has been discovered in submarine lava tubes off the coast of Maui. The inside of the lava tubes are very still, and the bottom is covered with a very fine sediment. In this quiet environment the acorn worms live on top of the sediment. Usually part of the body is covered with a thin layer of sand. The photo of the head (above) was taken at the opening to the lava tube, where large pieces of sediment had drifted in.*

41, 42 - *Flatworms may be very colorful or very drab. Most are carnivorous, and are often found under rubble. Flatworms are "thin-like-a-leaf," which distinguishes them from the relatively thick, but equally colorful, nudibranchs.*

40▲ 41▼

42▶

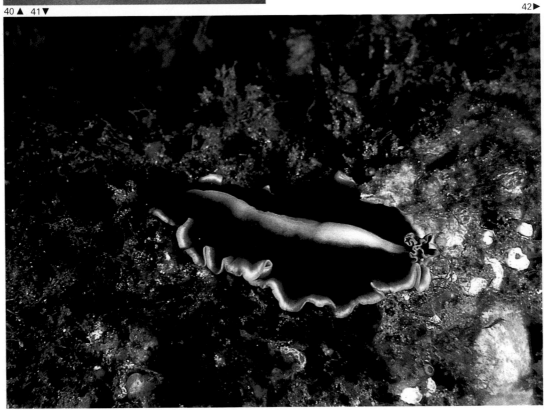

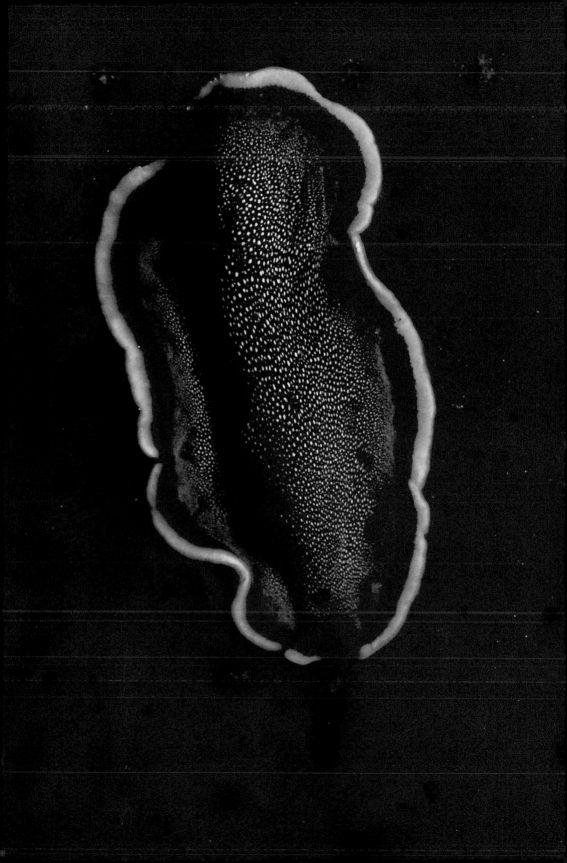

Segmented worms

43 - *The spaghetti worm,* **Loimia medusa***, stretches many white tentacles across the bottom in search of food. Each tentacle bears a groove along its length, and cilia lining the groove carry food to the mouth. The soft body is protected by a tube buried in the reef.*

44 - *The bristleworm* **Pherecardia striata** *is a free-living carnivore. It can give a painful sting with the white bristles that line the body.*

45 - *The featherduster worm* **Sabellastarte sanctijosephi** *secretes a soft tube of parchment to protect the body and extends a feathery crown to catch plankton. Tiny pigment spots on the crown are light sensitive, and the worm quickly contracts if a predatory shadow appears.*

46 - *The Christmas tree worm,* **Spirobranchus giganteus***, lives in a tube buried in living lobe coral with only its two feeding fans visible. These worms come in many different colors. They are able to retreat rapidly into their tubes when alarmed, and close them with a trapdoor called an operculum.*

43▲

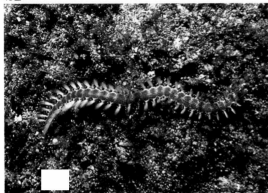

44 ▲ 45▼

46▶

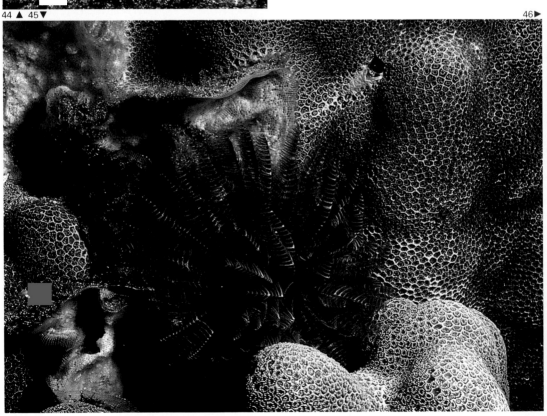

68

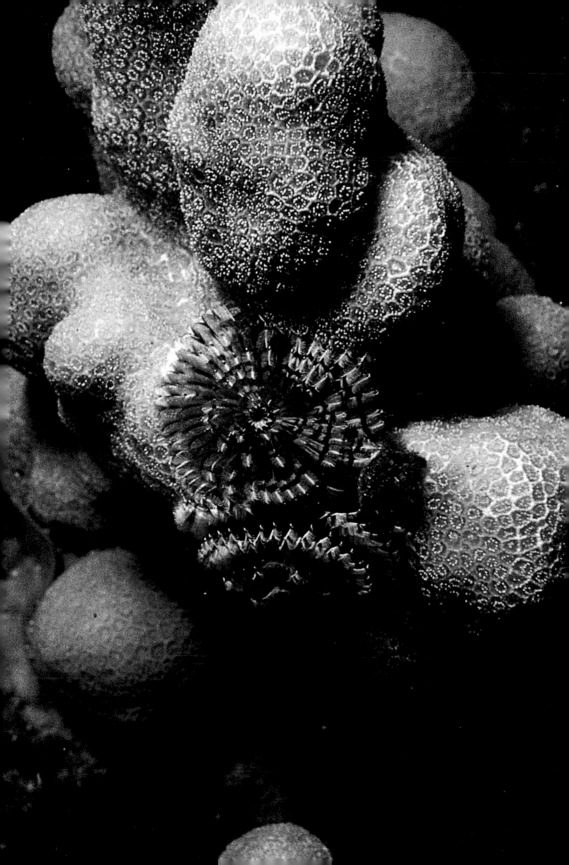

Mollusks

47 - Pen shells, **Pinna muricata**, are bivalves with thin, triangular shells that have a mother-of-pearl nacre on the inside. They are common in soft, silty sand from shallow water to depths of 100 meters. They form large beds in sand in deeper water.

48 - The triton's trumpet, **Charonia tritonis**, is a large shell reaching 50 cm in length. It feeds on sea stars and sea urchins, and is found at depths from 3 to at least 25 meters.

49 - Cowries produce oval, glossy shells that are favorites of shell collectors. The mantle, a shell-secreting organ that often covers the entire outside of the cowry's shell, keeps it repaired and polished. It also serves to camouflage the cowry, as its coloration blends in with the surroundings. The tiger cowry, **Cypraea tigris**, grows to its maximum size of 18 cm in Hawaiian waters.

50 - The helmet shell, **Cassis cornuta**, reaches about 30 cm in length. The shells of females are larger and have short knobs, while the shells of males are smaller and have long knobs. This photo is of a male. Helmet shells live in sand at depths between 3 and 60 meters.

47▲

48▲ 49▼

50▶

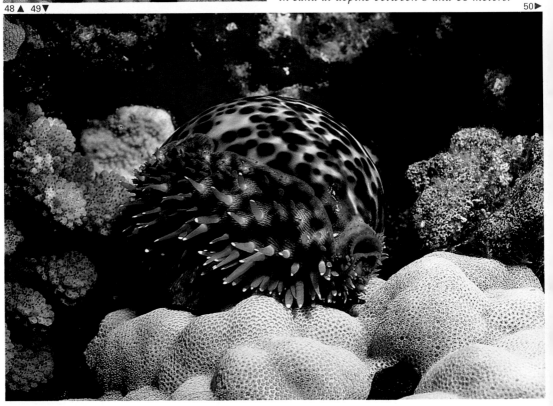

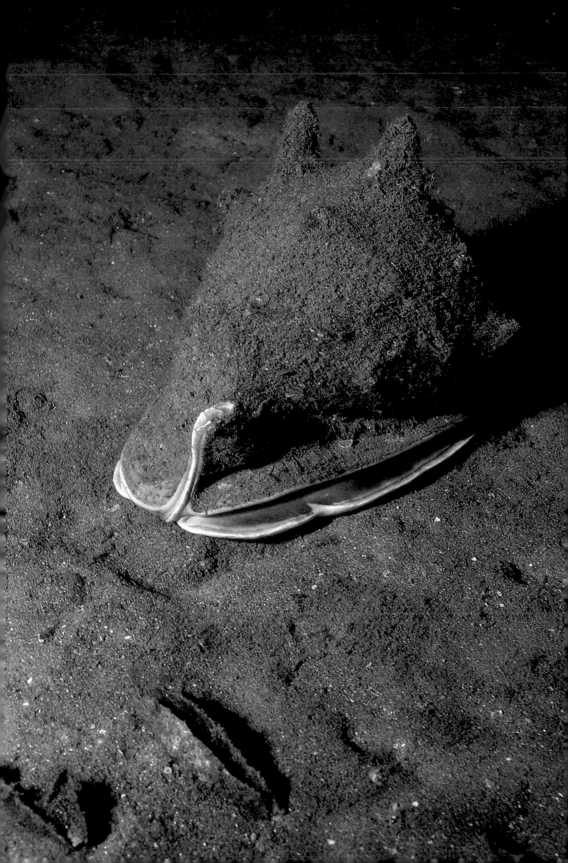

Nudibranchs

Nudibranchs are snails without shells.

51 - *The Spanish dancer,* **Hexabranchus sanguineus**, *is a dorid nudibranch. Dorids have a ring of feathery gills encircling the anus. This species is quite commonly encountered in tidepools as well as in deeper areas, where it feeds on sponges. This is a large species, reaching 18 cm.*

52 - **Pteraeolidia ianthina**, *is an aeolid nudibranch. Members of this group bear projections, called cerata, along their backs which contain extensions of the digestive tract. They feed primarily on cnidarians which contain stinging cells (nematocysts). They are able to ingest these cells then store them in the cerata for their own defense. This species feeds on hydroids.*

53 - **Phyllidia varicosa** *is a daytime feeder on sponges which contain toxic compounds. It protects itself by producing mucus containing these recycled toxic compounds.*

54 - *This bright red rose is actually the egg mass of the Spanish dancer. It appears lavender at depths exceeding 3 meters as red wave-lengths are quickly lost when they enter the water.*

51▲

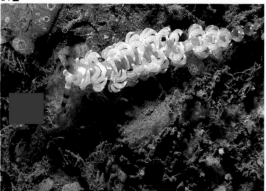

52 ▲ 53▼

54▶

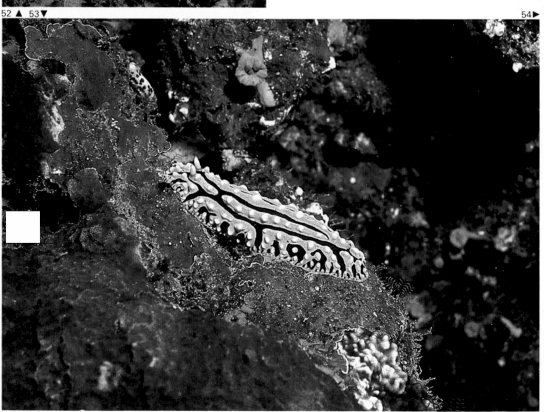

55 - *The gold lace nudibranch,* **Halgerda terramtuentis**, *is a sponge feeder found in ledges and caves from 2 to 30 meters. This is a dorid nudibranch with feathery gills around the anus.*

56 - **Glossodoris youngbleuthi**, *another dorid, lives in ledges and caves at depths ranging between 2 and 20 meters. It is nearly always found on the dark gray sponge on which it feeds.*

Octopus

Like the nudibranchs, the octopus is a mollusk without a shell. Octopus have eight muscular arms and very good eyesight. They are probably the most intelligent of the invertebrates. Locally they may be called "he'e," "tako," or "squid." They are not properly a squid, as that group of animals has an additional 2 tentacles, for a total of 10 appendages.

57 - **Octopus ornatus**, *"he'e pūloa" is active at night. The bright white spots are characteristic of this species. It lives in holes in the reef by day and comes out at night to feed. Here it is seen emitting a cloud of ink as a defense.*

58 - **Octopus cyanea**, *"he'e mauli," is active during the day. It lives in holes at depths ranging from shallow reef flats to 50 meters, and preys on mollusks, crabs, and shrimp. It has a strong beak and its bite can be painful.*

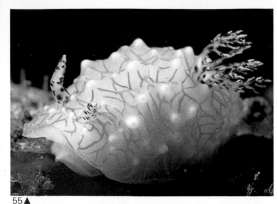
55▲

56 ▲ 57▼

58▶

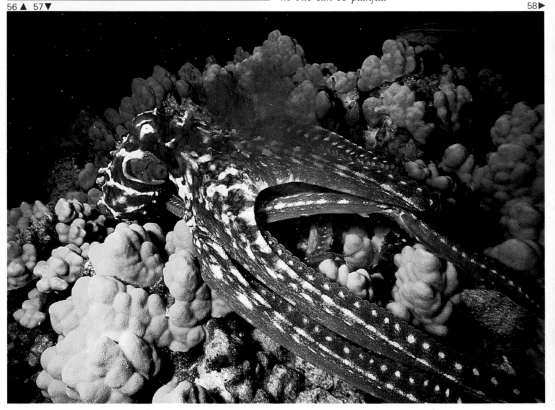

Crustaceans

Crustaceans are often not seen by the casual diver. They are very secretive in the day, coming out at night to feed.

59 - The cleaner shrimp, **Lysmata amboinesis**, picks parasites off fishes. The bright white antennae advertise its presence.

60 - The candy cane shrimp, **Parhippolyte uveae**, is found in deep caves and lava tubes in Hawai'i. It has a red and white banded pattern and extremely long, thin legs and antennae. They are usually found in groups. In other parts of the world this shrimp is found in brackish ponds and is bright red in color.

61 - The banded coral shrimp, **Stenopus hispidus**, is found in tropical seas around the world. They usually occur in pairs and are found in crevices and under ledges from tidepools to deeper water. The third pair of legs are the largest and can be dropped as a defense, then regenerated later.

62 - The harlequin shrimp, **Hymenocera picta**, is usually found in pairs feeding on starfish. The gaudy coloration may inhibit attacks by fishes, as it is rarely preyed upon.

59▲

60 ▲ 61▼

62▶

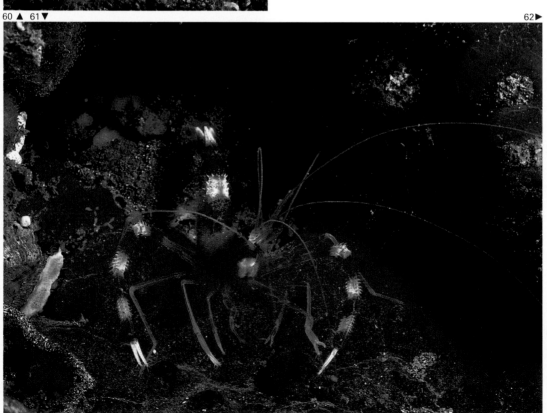

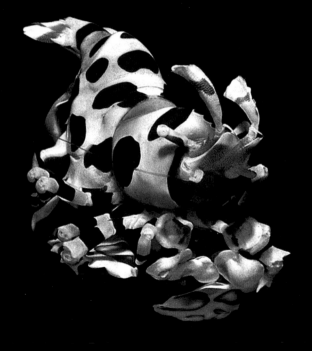

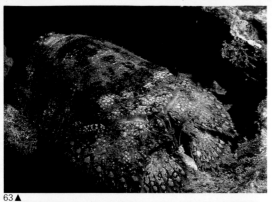

63 ▲

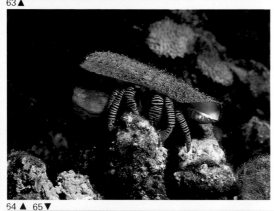

64 ▲ 65 ▼

63 - *The slipper lobster,* **Parribacus antarcticus** *is a common species on shallow reef flats. It is most active at night. It reaches about 20 cm in length.*

64 - *The hermit crab* **Trizopagurus strigatus** *is easily recognized by the red and yellow bands encircling the legs. This species has a greatly flattened body suitable for inhabiting cone shells.*

65, 66 - *The hermit crab* **Aniculus maximus** *is easily recognized by its large size and hairy, yellow legs. It inhabits large shells such as the triton's trumpet (right) and tun shells (below).*

66 ▶

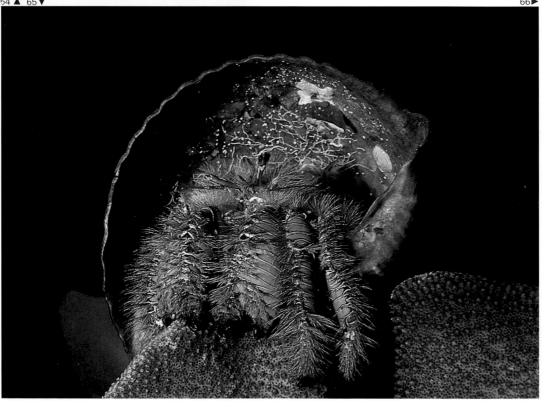

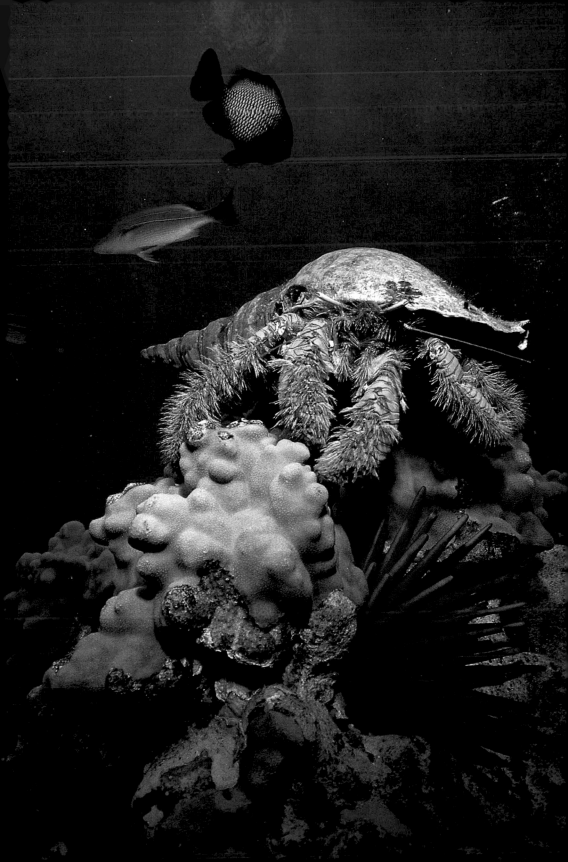

67 ▲

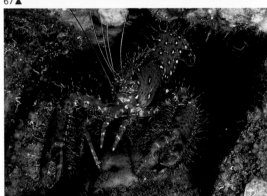

68 ▲ 69 ▼

67 - *The mole lobster ,* **Palinurella wieneckii,** *is found in the deep recesses of submarine lava tubes. It belongs to a family of lobsters that is intermediate between the spiny and slipper lobsters. The average size is about 14 cm in length.*

68 - *The Hawaiian lobster,* **Enoplometopus occidentalis,** *is related to the Maine lobster. One obvious thing they have in common is the presence of claws. These lobsters are only about 20 cm in length and are found in caves and reef crevices.*

69 - *The spiny lobster,* **Panulirus marginatus,** *"ula," is found in caves and under ledges. Spiny lobsters do not have claws. The body may reach 40 cm in length.*

70 - *The slipper lobster,* **Scyllarides haanii,** *"ula papa," is closely related to the spiny lobster, but has a flattened body and lacks long antennae. Slipper lobsters rely on camouflage for defense. This species reaches 30 cm in length.*

70 ▶

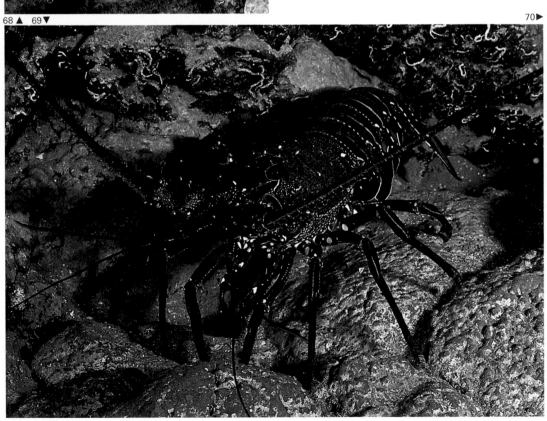

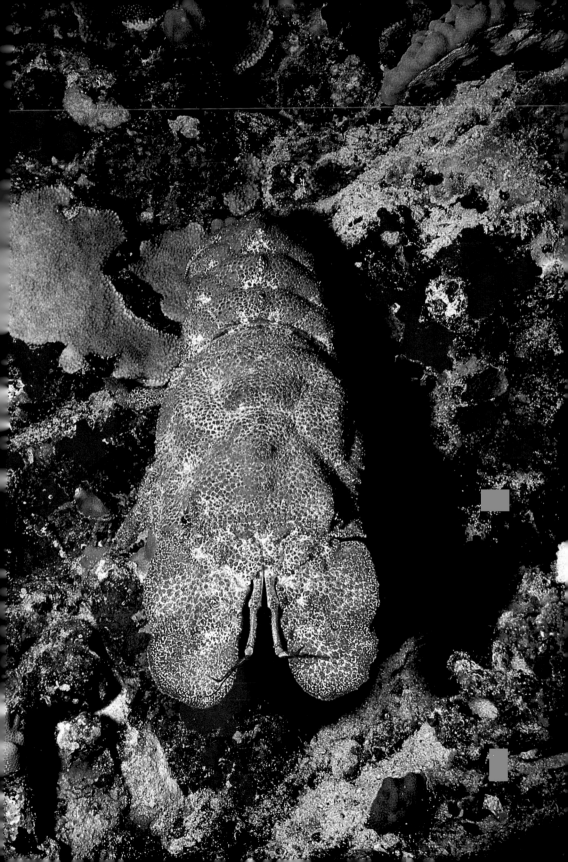

71 ▲

72 ▲ 73 ▼

74 ▶

71 - *Shrimp of the genus* **Rhyncocinetes** *are usually very colorful. This specimen is a male, as only old males develop the clawlike processes on the front legs. Specimens are 2.5 – 5 cm. in length.*

72 - *The long-handed spiny lobster,* **Justitia longimana,** *can be recognized by the red and white bands encircling the antennae and legs. This rare lobster reaches about 15 cm. in length.*

73 - *The tiny shrimp,* **Periclimenes soror,** *lives commensally on the cushion sea star and crown-of-thorns sea star. It is about 6 mm. in length.*

74 - *The dark and light striped shrimp,* **Stegopontonia commensalis,** *lives on the long spines of the venomous sea urchins. The white stripe helps to break up the silhouette of the shrimp. This shrimp is less than 2.5 cm. in length.*

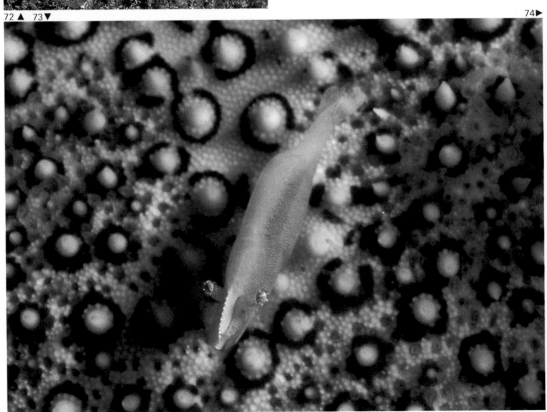

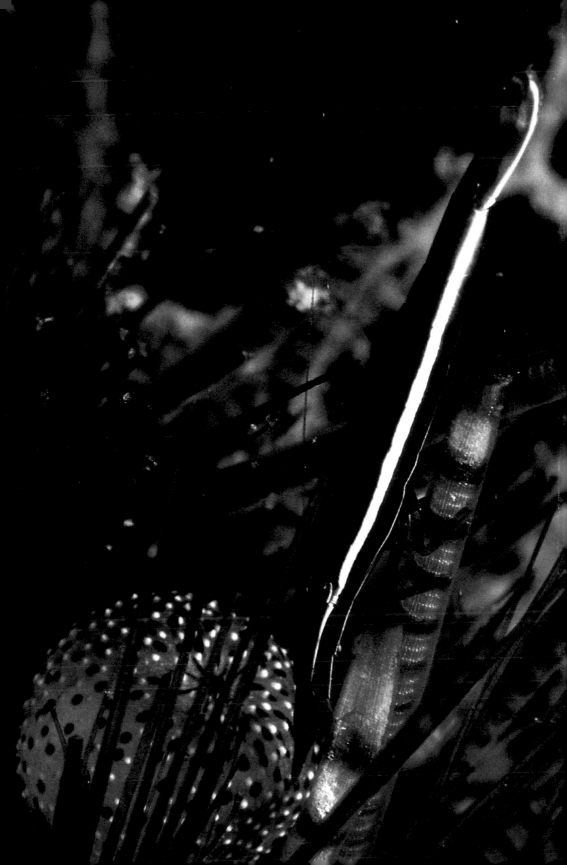

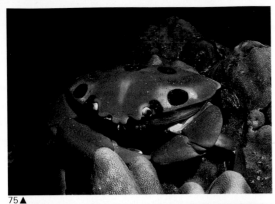

75 - *The 7-11 crab,* **Carpilius maculatus**, *is a large xanthid crab named for the dark spots on the body. The xanthid crabs are a very common group on the reef. They have oval bodies that are broader than long, large claws, and small legs. The strong claws are used to break open hard-shelled prey. The carapace of this species can be 15 cm across.*

76 - *The swimming crab,* **Charybdis hawaiiensis**, *is quite common and lives in crevices such as those formed by finger coral thickets and antler coral heads. Swimming crabs have a paddle-like fifth pair of legs. They are very quick and have sharp claws. Most species of swimming crabs live in the sand or mud and prey on fishes. The carapace width of this species reaches 8 cm.*

77 - *The sponge crab,* **Dromidiopsis dormia**, *is a large, slow crab that carries a sponge or colonial tunicate on its back. Occasionally it may choose a piece of flotsam, such as a rubber slipper. The last two pair of legs hold the sponge in place. The dark, fuzzy appearance of the crab allows it to blend in with the algae-covered surface, while the sponge or tunicate further enhances the disguise of being just another piece of reef.*

78 - **Etisus splendidus** *is a large, bright red xanthid crab. Many xanthid crabs have black fingers. The tips of the strong claws have a spoon shape. The carapace reaches a width of 18 cm.*

75▲

76 ▲ 77▼

78▶

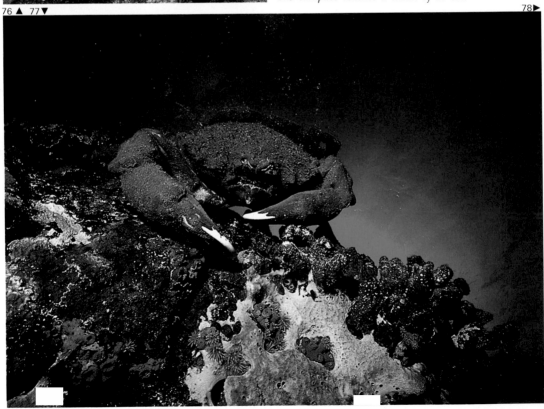

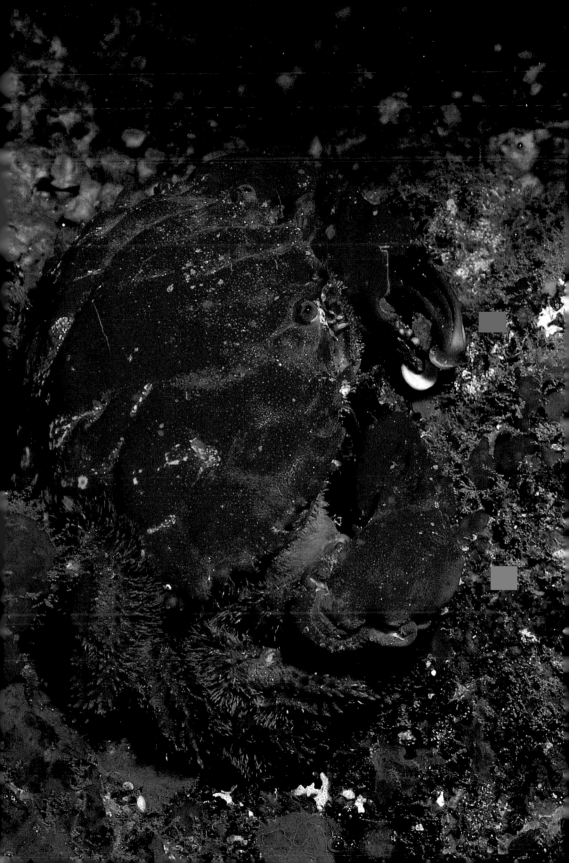

Bryozoans

79 – 81 - *Bryozoans are commonly called lace corals. Colonies are found on rocks, dead shells, and seaweeds, and are major fouling organisms on boat bottoms and pier pilings. They feed on plankton which is collected from the water by currents produced by the ciliated tentacles. The different growth forms of bryozoans are shown here, which include encrusting, upright, and branching forms. Colonies occur from the intertidal zone to great depths.*

82 - *This branching bryozoan is feeding. Notice the delicate, cone-shaped feeding fans lining the slender branches. Bryozoans are small, usually less than 8 cm in height or width.*

79▲

80 ▲ 81▼

82▶

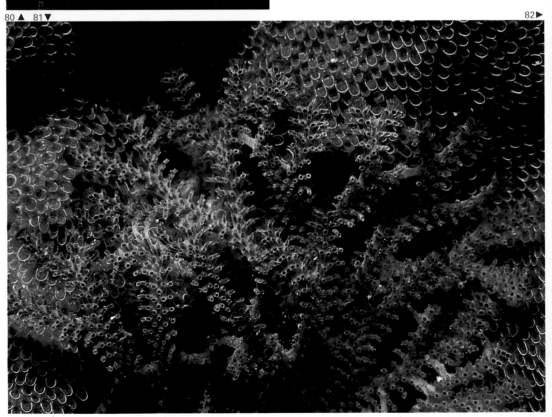

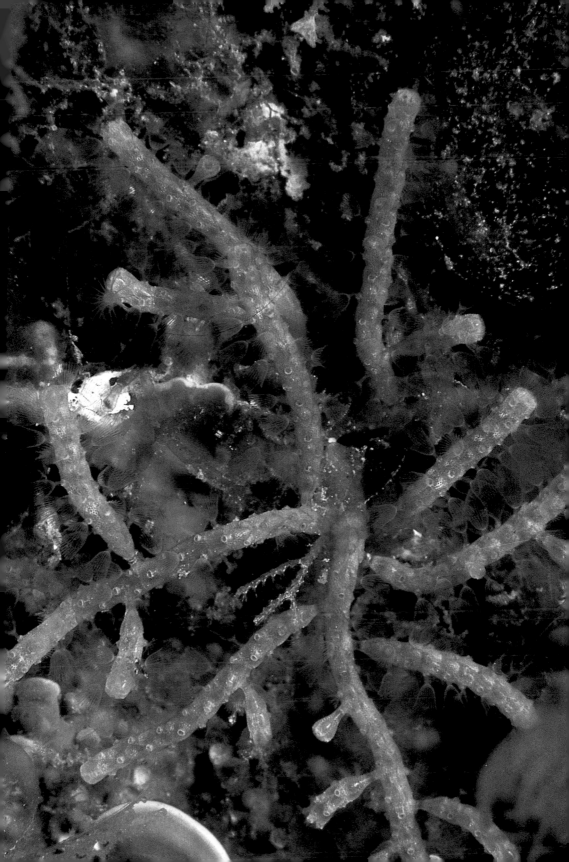

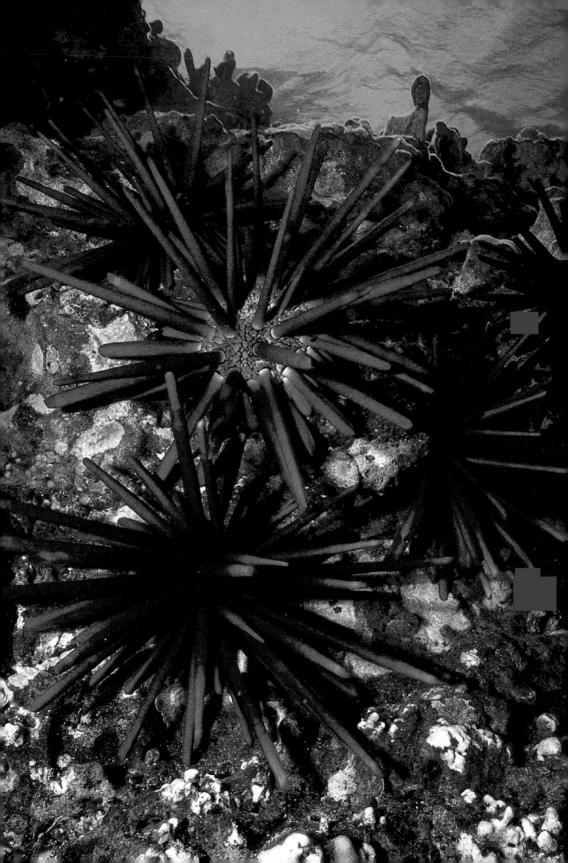

Echinoderms

The echinoderms all have tube feet that aid in attachment and locomotion. They have a 5-ray symmetry and an internal skeleton. This group of animals is only found in the ocean.

83 - The slate pencil sea urchin, **Heterocentrotus mammillatus**, is red. There are three types of spines: the long triangular spines on the top keep predators at bay; the shorter, flatter spines underneath clamp onto the reef; and many tiny spines encase and protect the body. This last type may be red or white in color.

84 - The pebble collector urchin, **Pseudoboletia indiana**, is found buried under rubble. The color ranges from pale lavender to purple. The average size is 15 cm. in diameter.

85 - The collector urchin, **Tripneustes gratilla**, "hawa'e," is usually seen with bits of debris on its back. This species is very common in shallow water, where it wanders about the reef feeding on seaweed. Large individuals are 15 cm. in diameter.

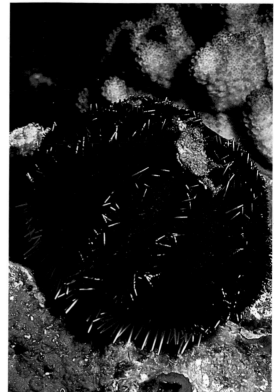

83◄

84▼ 85▲

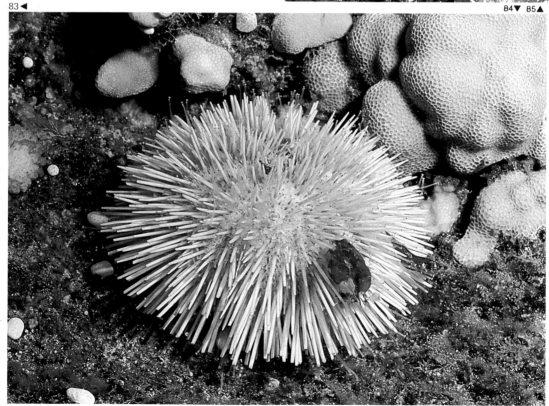

86 - *Urchins with long, needle-like spines may be venomous and should not be handled. The Hawaiian name for this type of urchin is "wana."* **Diadema paucispinum** *is black and has extremely long, thin spines.*

87 - **Echinothrix calamaris** *may be black and white banded or all black. A small crab is sometimes found living in the anal opening. Red sponges grow nearby.*

88 - **Echinothrix diadema** *is black with an iridescent blue sheen. It can be common in shallow areas. Zoanthid colonies grow beneath the urchin.*

86▲ 87▼

88▶

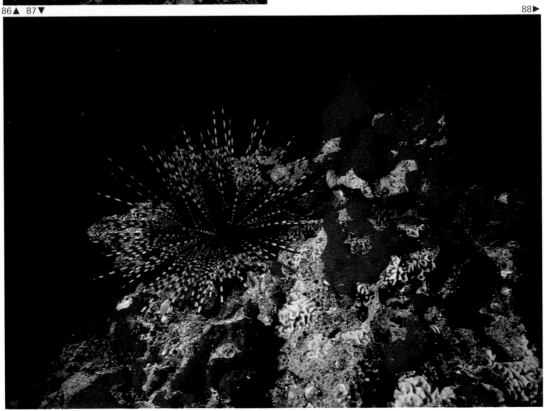

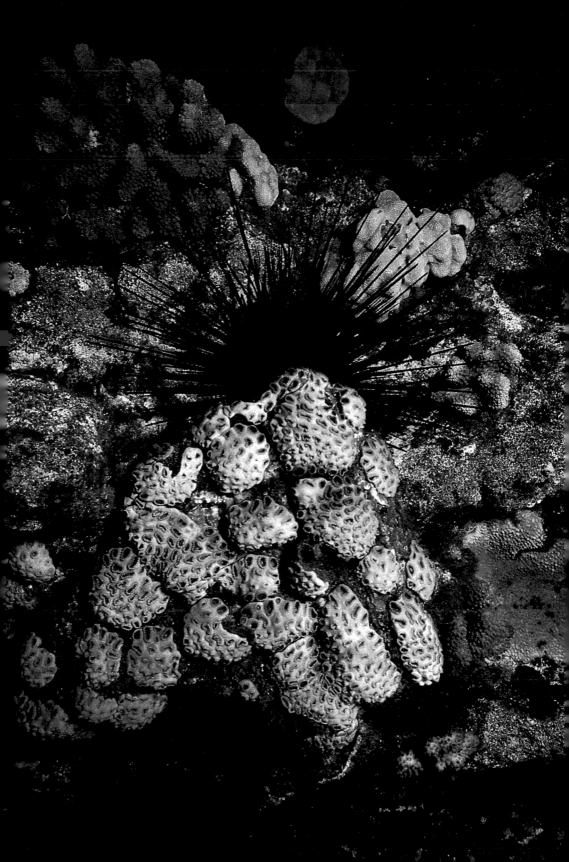

89 - *The green sea star,* **Linckia guildingi,** *is about 30 cm. from tip to tip. It is occasionally seen at depths of about 3 meters, but is more common in deeper water.*

90 - *Rows of hard spines protect the delicate tube feed and central mouth on the underside of the sea star.*

91 - *The common sea star* **Linckia multifora** *is found at a variety of depths on exposed reef surfaces. This sea star is able to reproduce asexually by breaking off an arm which then regenerates to form a new individual.*

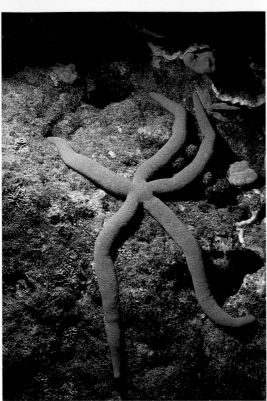

89 ▲ 90 ▼

91 ▶

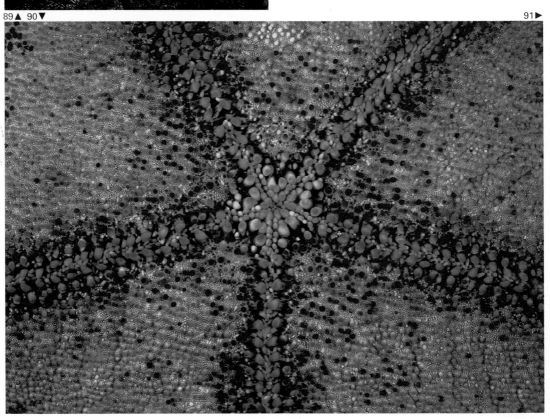

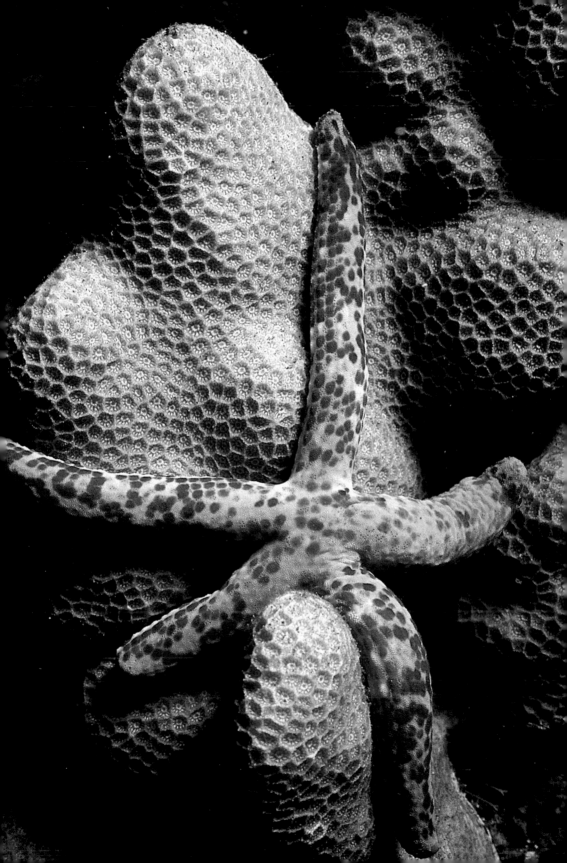

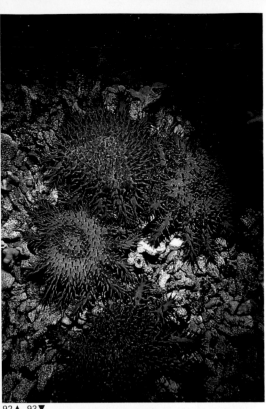

92 - *The crown-of-thorns sea star,* **Acanthaster planci**, *is well-known for its habit of feeding on living coral. Huge aggregations of these sea stars have killed living coral reefs all over the tropics. The upper surface is covered with sharp, venomous spines, while the underside has many rows of large tube feet.*

93 - *The red sea star* **Pentaceraster hawaiiensis**, *is an uncommon starfish occurring in deeper water. It is found on sand and has been seen feeding on beds of* **Pinna** *shells.*

94 - *The orange sea star* **Mithrodia fisheri** *is occasionally seen in deeper water. Some sea stars feed by extending the stomach wall through the mouth opening and dissolving the prey with digestive enzymes; others swallow their prey.*

92▲ 93▼ 94►

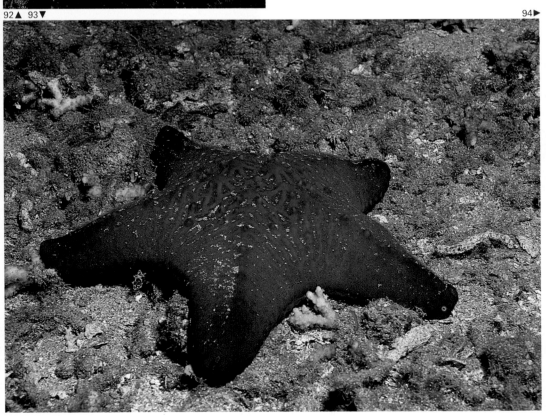

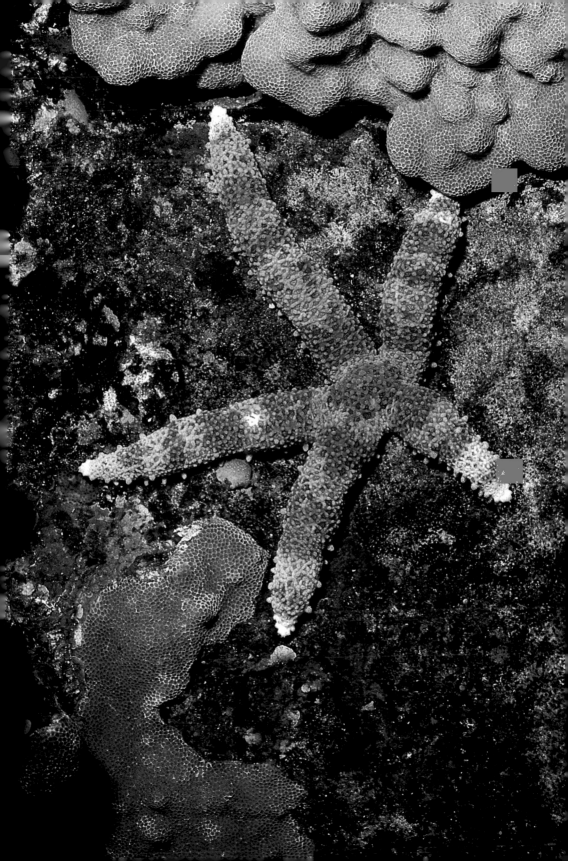

95 - *The brown sea cucumber* **Actinopyga obesa** *is yellowish-brown and has five yellow serrated teeth around the anal opening. This species is less common than* **A. mauritiania** *(below), and occurs in deeper, calmer water. It may reach 30 cm. in length when relaxed, but it contracts quickly when handled.*

96 - *The brown and white speckled sea cucumber* **Actinopyga mauritiania** *is common in areas of heavy surge. Its strong tube feet allow it to cling tenaciously to the reef. The opening to the anus is encircled by 5 white teeth. It reaches 20 cm. in length.*

97 - **Holothuria nobilis** *is a very large, rock-hard, black sea cucumber. The smooth surface is covered with sand. Along the base at each side of the body are 3 or 4 distinct projections, giving this species the common name of "teat-fish" in other parts of the Pacific. This species is highly prized for beche-de-mer, the dried cucumber used in Chinese cooking. It reaches 25 cm. in length. Another, more common species,* **Holothuria atra,** *may be confused with the above species, but* **H. atra** *has a softer body.*

98 - *As a defense mechanism, some species of sea cucumbers, such as this* **Bodhaschia paradoxa,** *eject white sticky threads called Cuverian tubules.*

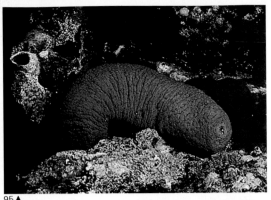

95 ▲

96 ▲ 97 ▼ 98 ►

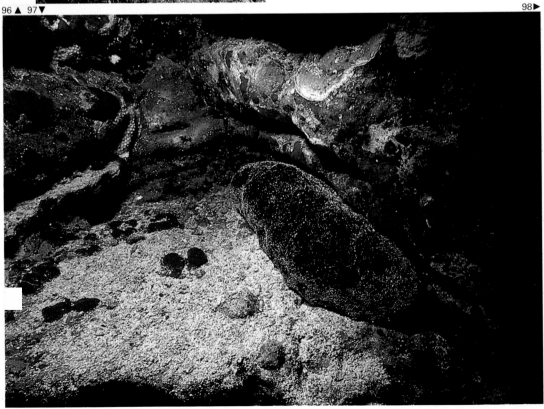

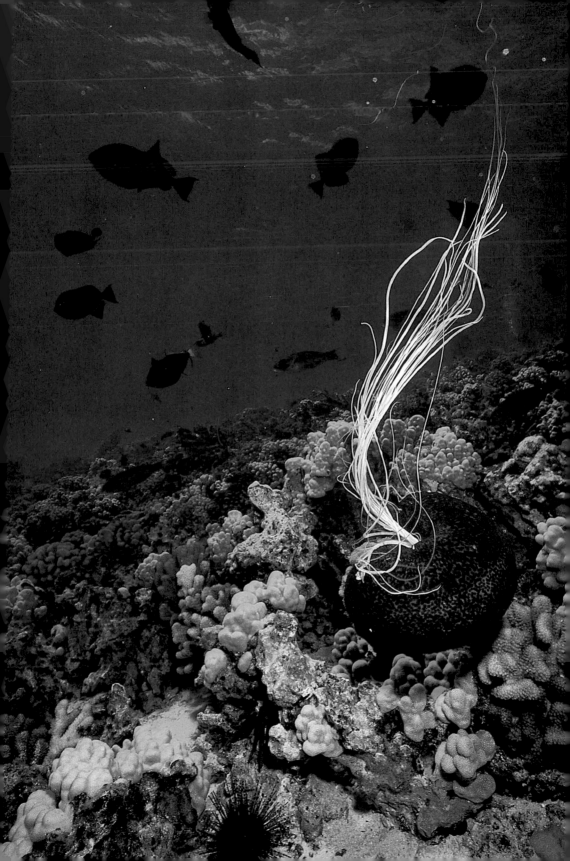

Sea cucumbers use their tube feet to move slowly over the reef surface, picking up organic material with sticky oral tentacles. Sea cucumbers are not harmful.

99, 100 - *The black sea cucumber* **Holothuria atra** *lives in sandy areas of the reef and is always covered with a thin layer of sand. This species may be confused with* **Holothuria nobilis;** *however,* **H. nobilis** *has a very wide, hard body, while* **H. atra** *is more slender and soft.*

101 - *The light-spotted sea cucumber* **Holothuria hilla** *has yellowish projections scattered over the brown body. It normally lives under rocks.*

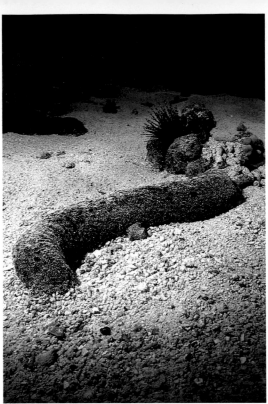

99▲ 100▼ 101▶

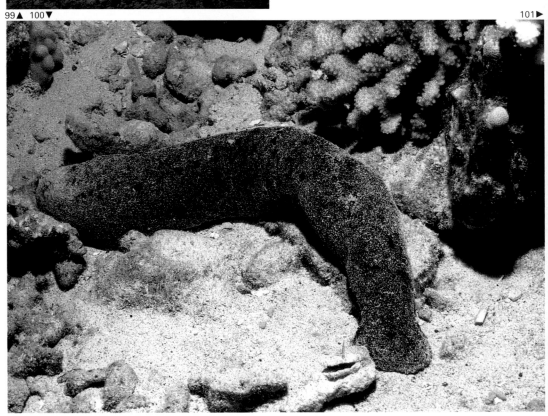

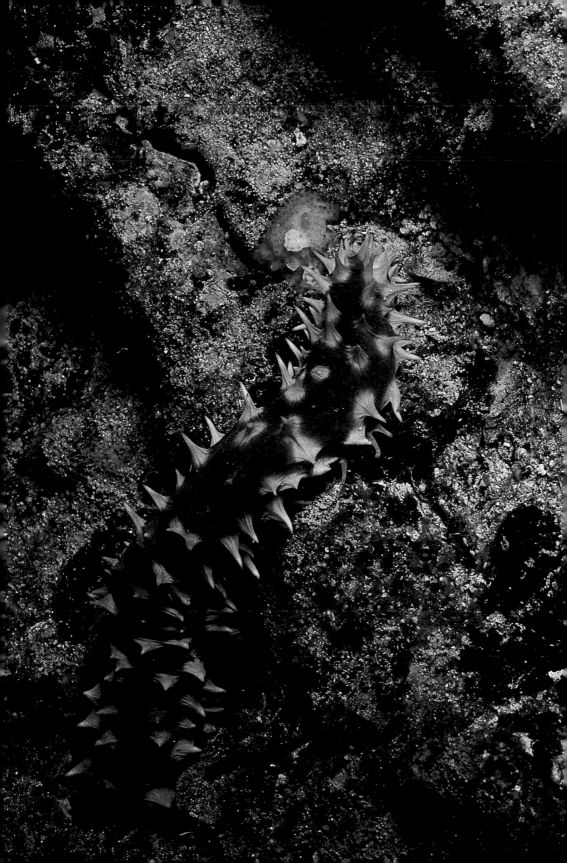

102▲

Tunicates

The phylum Chordata includes all the vertebrates (animals with backbones), and also some groups which are transitional between the invertebrates and vertebrates. Tunicates are one of these groups. They appear to be very simple filter-feeders, much like sponges. However, during the larval stages, these animals possess some very advanced characteristics which place them in the same major animal group (phylum) as humans. These advances are subsequently lost in the adult stage.

102, 105 - Tunicates can grow singly or in colonies. This ivory-colored colonial tunicate is commonly seen while scuba diving off Lāna'i.

103 - In this colony there are many small openings arranged around a few larger openings. Each small opening is the incurrent pore for an individual animal, or zooid. Several individuals then share a common excurrent pore for waste removal.

104 - This is a colony of many tiny, orange individual tunicates. Each has its own incurrent and excurrent opening.

103▲ 104▼

105▶

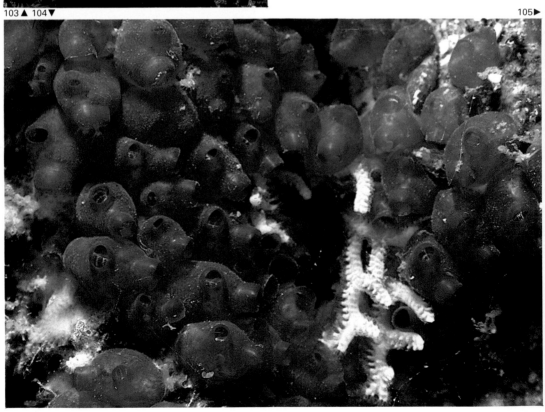

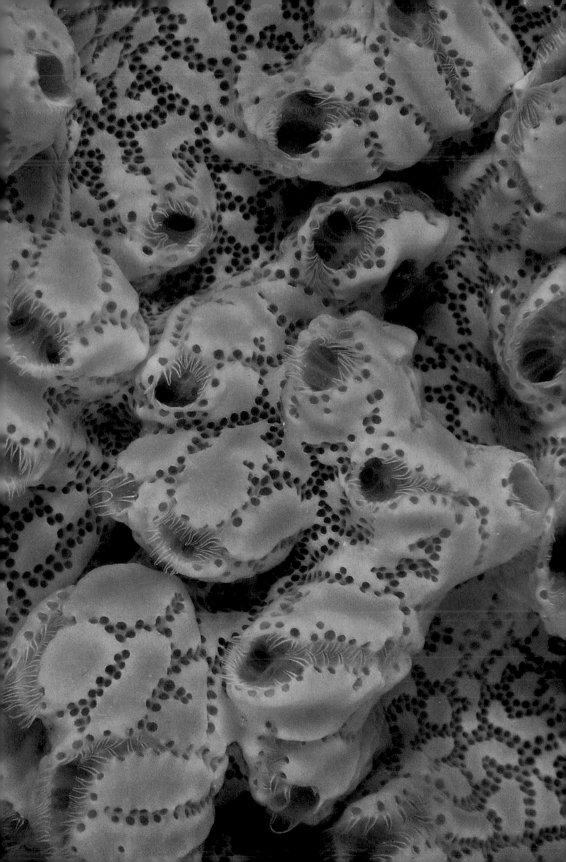

Sharks and rays

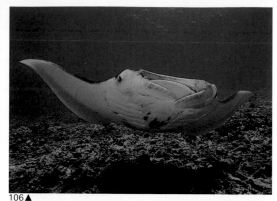

106 - *The manta ray,* **Manta alfredi**, *can be recognized by the two large flaps beneath the head which are used to funnel plankton into the mouth. This ray is harmless to humans because there is no barb on its long tail. The wingspan may reach 3.5 meters.*

107 - *The spotted eagle ray,* **Aetobatus narinari**, *bears a venomous barb at the base of the tail, and contact with this species should be avoided. The teeth of this species are fused to form a grinding plate in each jaw. The lower jaw is then used to dig in the sand to find mollusks which are crushed in the mouth. The wingspan may reach over 2 meters, but is usually 60 cm. – 1.2 meters.*

108 - *The whitetip reef shark,* **Triaenodon obesus**, *is easily recognized by the bright white tips on the dorsal and tail fins. This shark is often found resting in caves. It is not considered to be dangerous, but any sea creature with sharp teeth should be treated with respect. Size: usually 1 meter.*

109 - *The gray reef shark,* **Carcharhinus amblyrhynchos**, *is gray above and white beneath with a black trailing edge to the tail fin. The species is found in deeper water along the outer edge of the reef. It is territorial and potentially a dangerous shark. Size: over 2 meters.*

106▲

107▲ 108▼

109▶

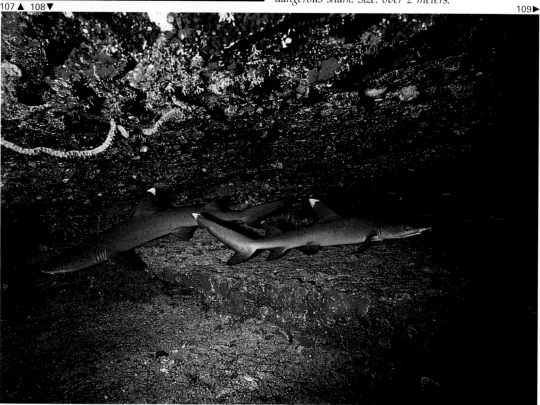

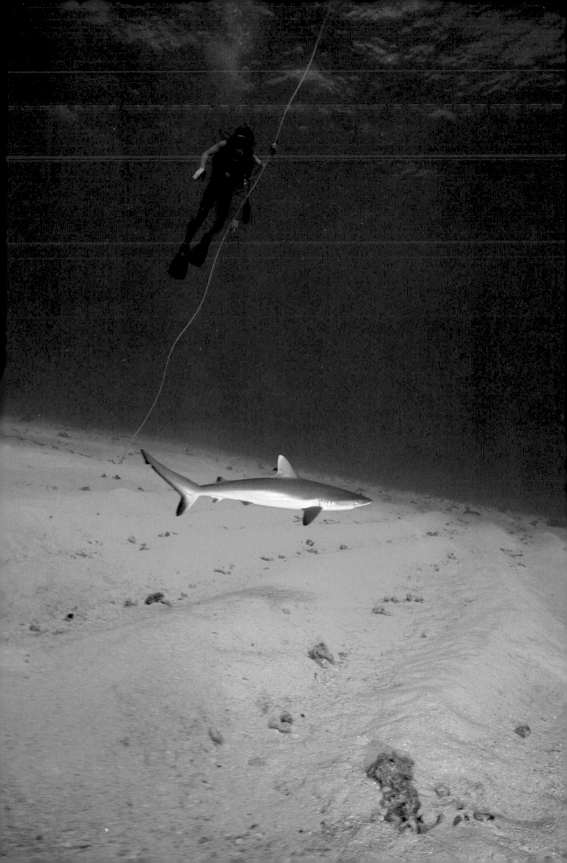

Eels

Eels spend most of their time within the reef structure, and their long, slick, muscular bodies are well-adapted to this habitat. Eels are only dangerous when provoked. The Hawaiian name is "puhi."

110 - *The whitemouth moray eel,* **Gymnothorax meleagris**, *is commonly seen in shallow reef areas with its head protruding from a crevice. This species has very sharp teeth which it uses to feed on small fish and crustaceans. It is occasionally tamed by scuba divers. Size: to 1 meter.*

111 - *The yellowmargin moray eel,* **Gymnothorax flavimarginatus**, *can be recognized by the very thin, bright yellow margin on the outer edge of the fins. It also may be tamed by scuba divers. This species is sensitive to stimuli given off by injured fish, on which it then preys. Size: to 1.2 meters.*

112 - *The snowflake moray eel,* **Echidna nebulosa**, *is a small, harmless eel often found among rubble in shallow water. It crushes small, hard-shelled prey with its pebble-like teeth. Size: average 45 cm.*

110▲ 111▼

112▶

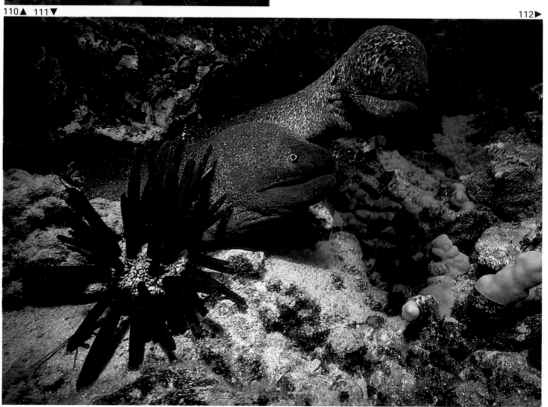

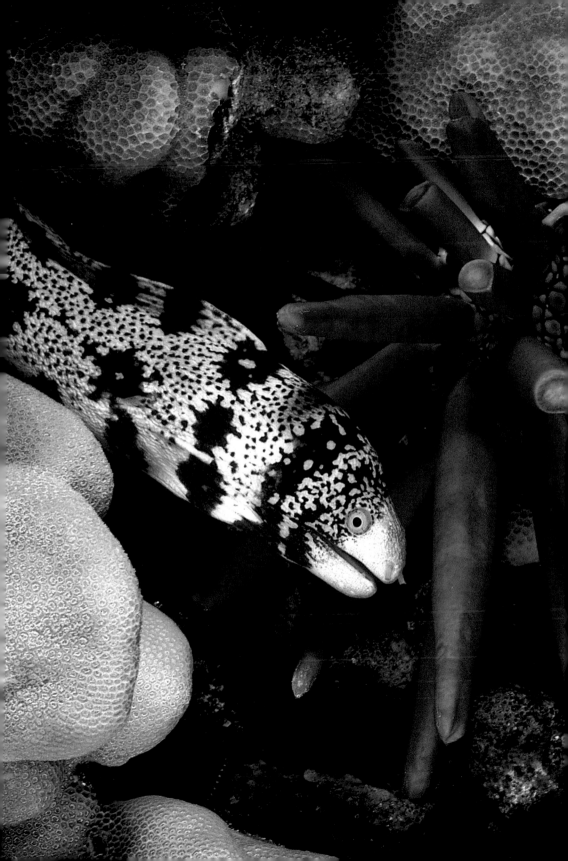

Elongated fishes

113▲

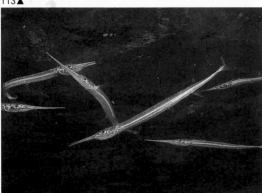

114▲ 115▼

113 - *The coronetfish,* **Fistularia commersonii,** *"nūnū peke," resembles the trumpetfish but can be distinguished from it by the long filament streaming from the tail and by the undulations of the body during swimming. This species is usually a pale green, but sometimes flashes a striped pattern. It preys on small fishes. Size: to 1 meter.*

114 - *Needlefishes, such as* **Tylosurus crocodilus,** *are long and slender carnivorous fish that live at the surface of the water. Their thin, silvery bodies are camouflaged in the sun-dappled surface waters. They are often seen inshore. At least four species are known from Hawai'i. They range from 30 cm. to 1.2 meters.*

115, 116 - *The trumpetfish,* **Aulostomus chinensis,** *"nūnū," has several color phases; the yellow and dark gray are shown here. The trumpetfish is a master of the sneak attack. The long body is often held in a vertical position, deceiving prey as to the size and shape of the predator. Locomotion is accomplished by the dorsal and anal fins, which are colorless and set far to the rear of the body, allowing the trumpetfish to move without appearing to swim. The various color phases allow it to blend in with the environment. The yellow color is often seen when yellow tangs are common in the vicinity. Size: to 60 cm.*

116▶

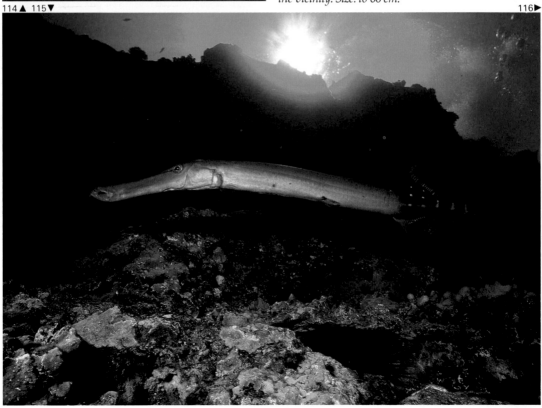

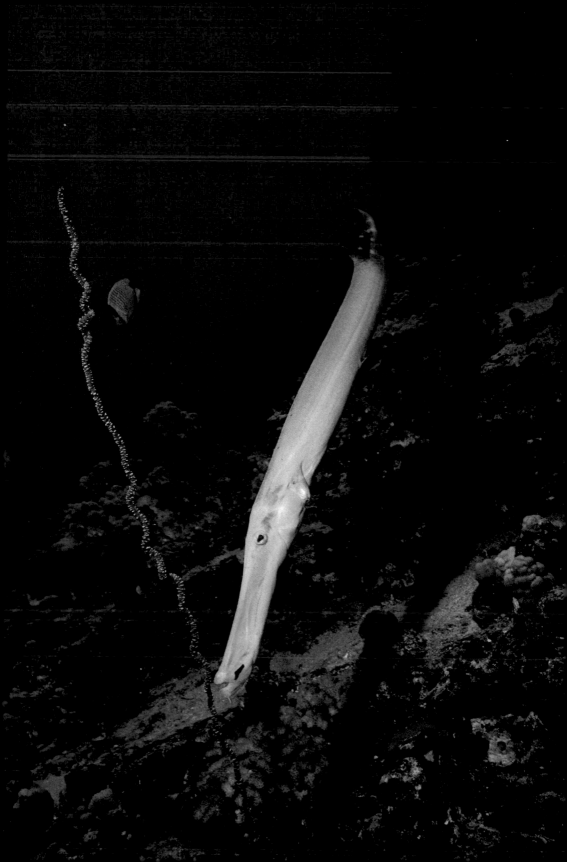

Night feeders

117, 120 - *Red fishes with large eyes are usually night feeders. The shoulderbar soldierfish,* **Myripristis kuntee**, *"ū'ū," feeds at night on crustacean larvae in the plankton. During the day this fish can be found in large schools under overhangs and in caves. Size: to 18 cm.*

118 - *The Hawaiian squirrelfish,* **Sargocentron xantherythrum**, *"ala'ihi," is found in crevices and caves in water deeper than 6 meters. This nocturnal predator feeds on bottom-dwelling crustaceans such as crabs and shrimp. This fish his known only from Hawai'i. Size: to 18 cm.*

119 - *The Hawaiian bigeye,* **Heteropriacanthus cruentatus**, *"aweoweo," is also active at night. There are four bigeyes in Hawai'i; two species are found in shallow water. This one is bright red, while the other shallow water species is red with silver mottling. They both hide in the reef's shadows by day. The large glassy eye and upturned mouth help in feeding on plankton at night. Size: to 30 cm.*

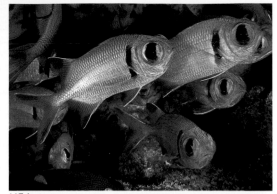

117▲

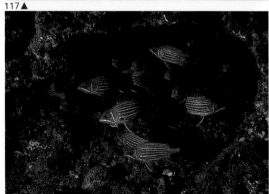

118▲ 119▼

120▶

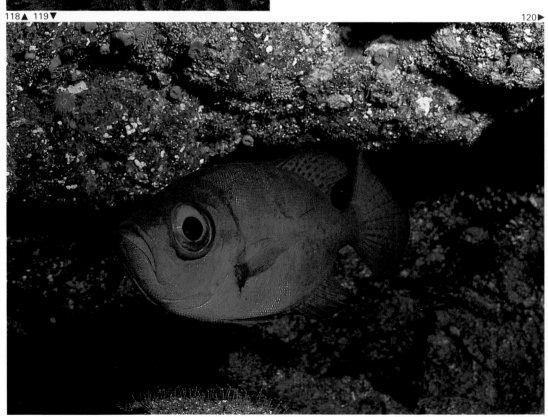

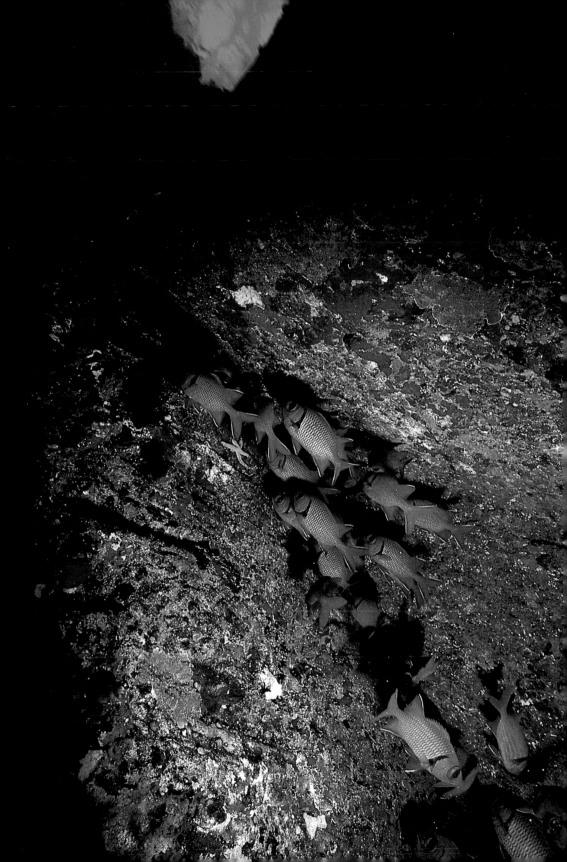

Goatfishes

Goatfishes have a pair of sensory barbels under the chin for probing around rocks and in sand for food.

121 - *The yellowstripe goatfish,* **Mulloidichthys flavolineatus**, *"weke," is commonly seen feeding in the sand alone or in small groups. This species may also occur in large schools hovering quietly over the reef. When schooling, the yellow stripe on the side is prominent, but when feeding alone the stripe fades and the spot is more noticeable. Size: to 45 cm. Photo by N. Harris.*

122, 124 - *The yellowfin goatfish,* **Mulloidichthys vanicolensis**, *"weke'ula," closely resembles the yellowstripe goatfish but is quite variable in color, ranging from white and yellow to pink. It is often found resting in quiet schools over sand patches or reef areas and under overhangs. It is a nocturnal predator on sand-dwelling invertebrates. Size: averages 25 cm. Photo by J. Randall.*

123 - *The blue goatfish,* **Parupeneus cyclostomus**, *"moano ūkali," is one of the largest of the goatfish, reaching 60 cm. in length. Feeding groups are often accompanied by one or two blue jacks, "ulua." The full Hawaiian name "moano ūkali ulua," means "moano with ulua following." This species mainly feeds on small fishes during the day.*

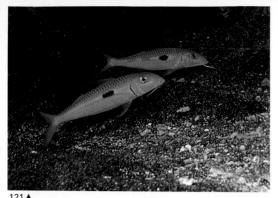

121▲

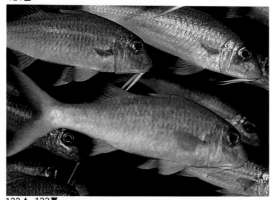

122▲ 123▼

124▶

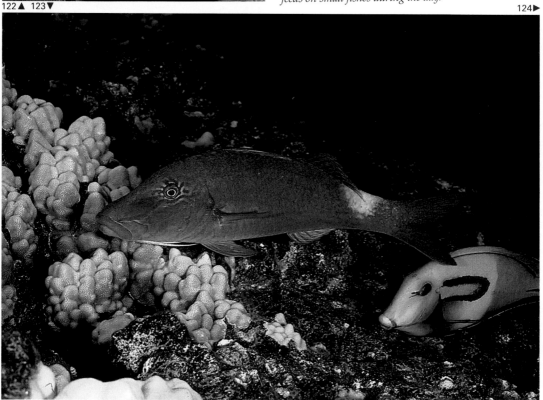

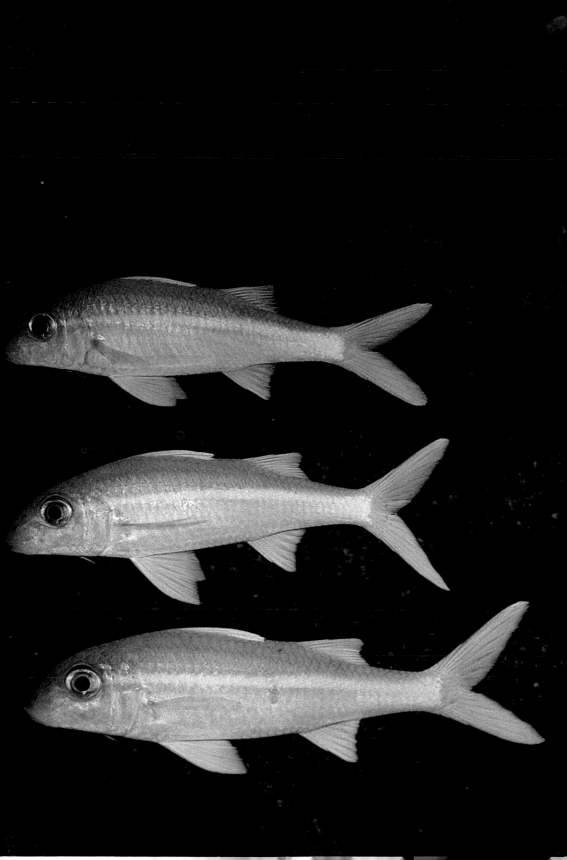

125 - *The doublebar goatfish,* **Parupeneus bifasciatus,** *is easily confused with the manybar goatfish. It is distinguished by a large white area at the base of a dark, purplish tail and is generally larger and more lavender in appearance than the manybar. Size: to 45 cm.*

127 - *The whitesaddle goatfish,* **Parupeneus porphyreus,** *"kumu," is a nocturnal predator on small crabs and other invertebrates. During the day it stays close to cover under ledges where it may occur singly or in small groups. Size: to 41 cm.*

126, 128 - *The manybar goatfish,* **Parupeneus multifasciatus,** *"moano," is seen alone or in groups of 2 to 3 searching for food in cracks and crevices in the reef. This is a daytime feeder on crabs and shrimp. The color can vary remarkably, from dark gray and white to a deep rosy pink. It is seen here in its normal reef color, and also in rosy pink while at a "cleaning station." (right) Size: to 30 cm.*

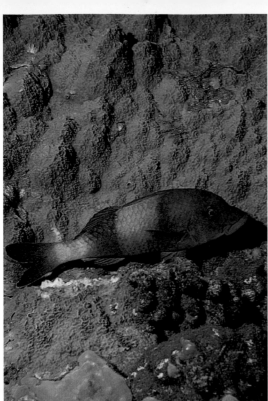

125▲ 126▼

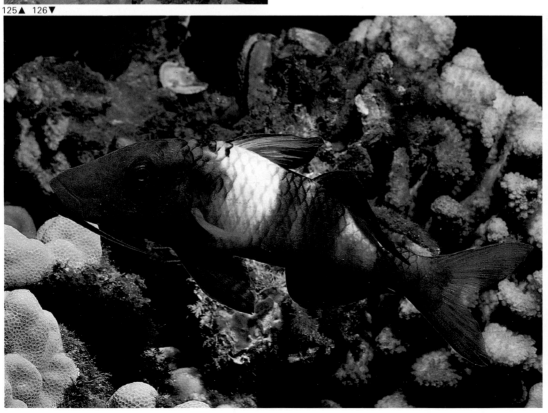

Butterflyfishes

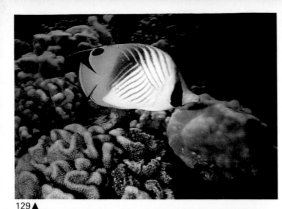

129▲

Butterflyfishes are highly maneuverable and slip easily into crevices in the reef. Most fishes in this family have a dark band through the eye. Many have an ocelli, or eye spot, on the body, which may confuse a predator as to which is the head end. They often have a different color pattern at night.

129 - The threadfin butterflyfish, **Chaetondon auriga**, is one of the larger butterflyfishes, reaching 23 cm in length. It feeds on bottom-dwelling invertebrates, usually in pairs.

130 - The saddleback butterflyfish, **Chaetodon ephippium**, also swims in pairs. This species feeds on coral and coral mucus. The average size is 18 cm.

131 - The ornate butterflyfish, **Chaetodon ornatissimus**, also swims in pairs. This species is found in coral rich areas where it feeds on corals and the mucus produced by corals. Size: to 18 cm.

132 - The racoon butterflyfish, **Chaetodon lunula**, occurs on shallow reefs and steep dropoffs. It may occur singly or in large groups. The average size is 18 cm.

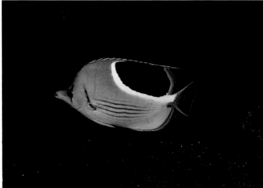

130▲ 131▼

132►

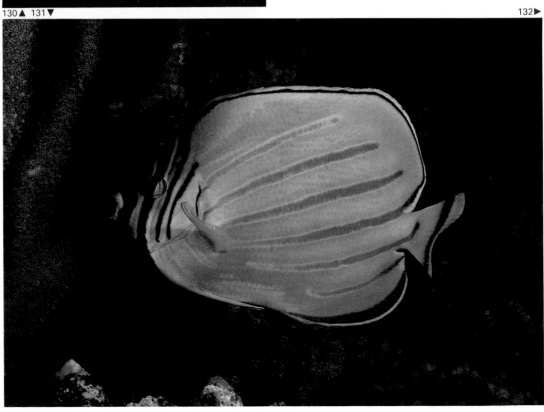

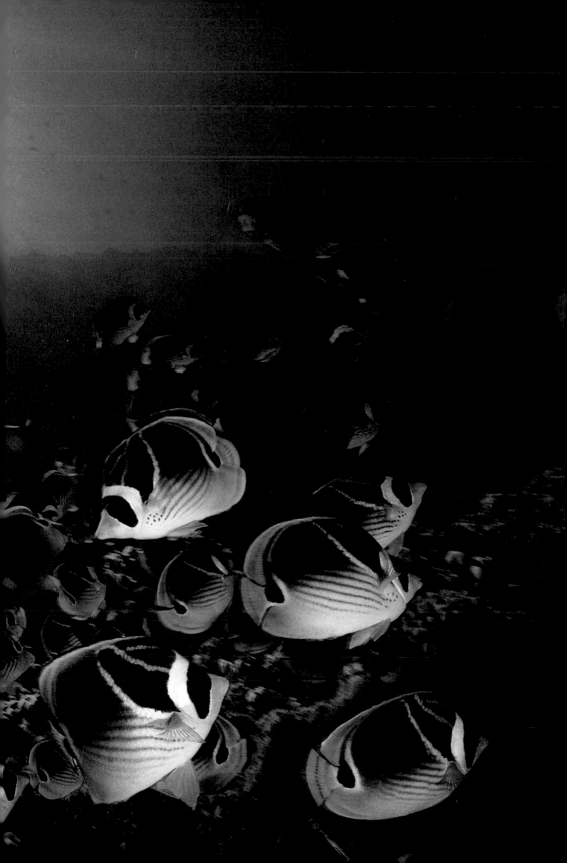

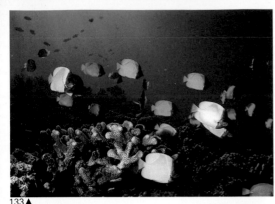

133 ▲

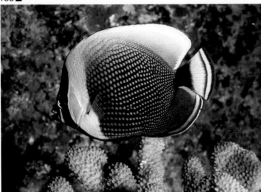

134 ▲ 135 ▼

133 - *The pyramid butterflyfish,* **Hemitau-richthys polylepis,** *feeds on plankton and on the lavender octocoral* **Anthelia edmondsoni.** *They are found in schools in dropoff areas rich in plankton. At dusk individuals defend a shelter area on the reef from other fish by darkening the white area on their sides and flashing a white spot in the center. Size: 13-18 cm.*

134 - *The reticulated butterflyfish,* **Chaetodon reticulatus,** *reportedly feeds on coral polyps. This is not a common species. To 15 cm.*

135 - *The bluestripe butterflyfish,* **Chaetodon fremblii,** *is found only in the Hawaiian Islands. It is often seen feeding in sandy areas near rocky outcrops, where it tears off pieces of bottom-dwelling invertebrates. Size: to 15 cm.*

136 - *The multiband butterflyfish,* **Chaetodon multicinctus,** *is also found only in the Hawaiian area. It occurs in pairs in shallow coral-rich areas where it feeds on coral polyps. This is a small species, reaching only 10 cm. in length.*

136 ▶

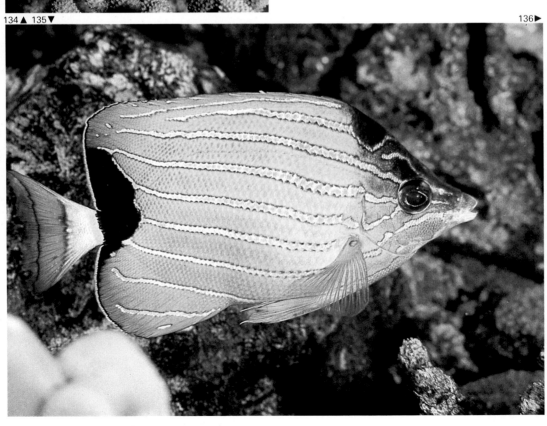

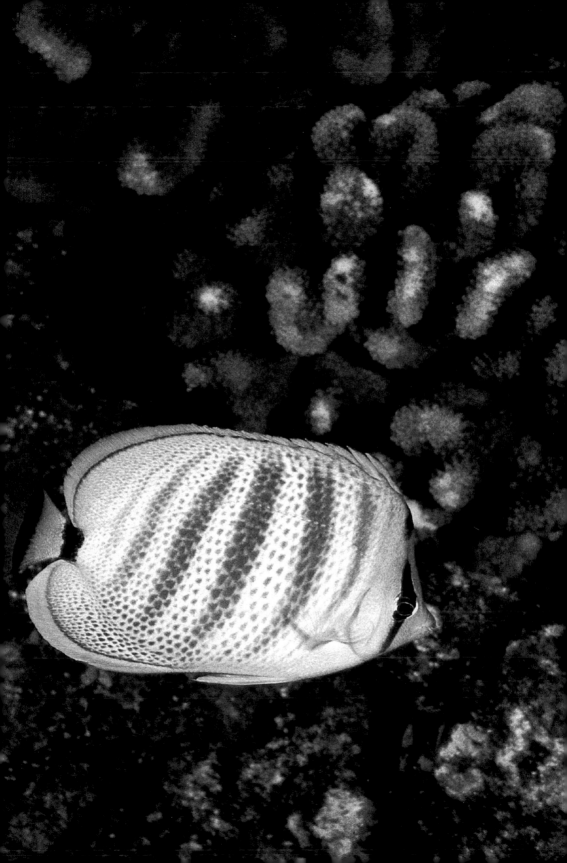

137 - *The oval butterflyfish,* **Chaetodon lunulatus***, is found in pairs in coral-rich areas and feeds on coral polyps. Size: 10–12 cm.*

138 - *The teardrop butterflyfish,* **Chaetodon unimaculatus***, is found in coral-rich areas where it feeds on coral tissue. It occurs in pairs or small aggregations. Size: about 12 cm.*

139 - *The forcepsfish,* **Forcipiger flavissimus***, "lau-wili-nukunuku-oioi" is one of two similar-looking fishes. The other, the long-nose butterflyfish,* **Forcipiger longirostris***, has a longer snout, is occasionally black, and is much less common. The snout of the forcepsfish bears many rows of sharp, inwardly curving teeth at the tip, which are used to grip and tear pieces off bottom dwelling animals. Size: to 23 cm.*

140 - *The fourspot butterflyfish,* **Chaetodon quadrimaculatus***, is found in pairs. It occurs in shallow water over coral heads, where it feeds on living coral and bottom-dwelling invertebrates. The two white spots on each side are the distinguishing feature of this species. Size: to 15 cm.*

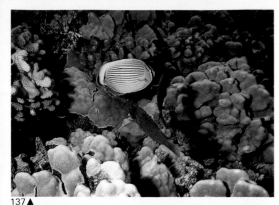

137▲

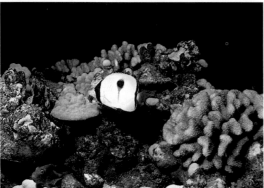

138▲ 139▼

140▶

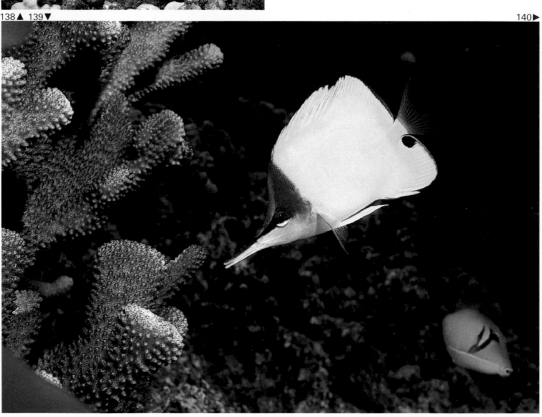

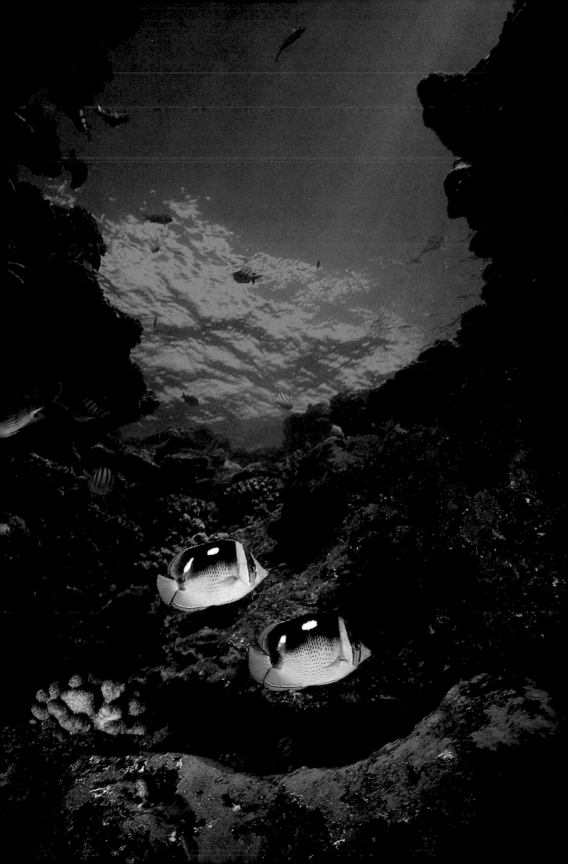

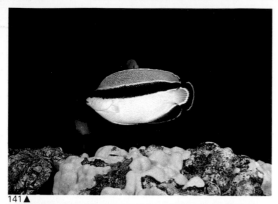

141▲

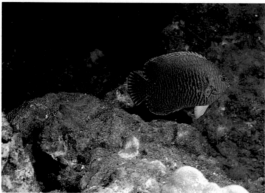

142▲ 143▼

Angelfishes are closely related to butterflyfishes and are distinguished from them by having a sharp spine at the lower edge of the gill cover in front of the pectoral fin. Hawai'i lacks the large, colorful angelfishes of other tropical areas.

141 - *The bandit angelfish,* **Holacanthus arcuatus**, *is found only in Hawai'i. It occurs at depths exceeding 10 meters, where it feeds mainly on sponges. It reaches 18 cm in length.*

142 - *The small Potter's angelfish,* **Centropyge potteri**, *is the most common shallow-water angelfish. It is found among finger coral, where it lives in a well-defined area on the reef. It is shy and stays close to cover. It is about 8-10 cm in length.*

143, 144 - *The milletseed butterflyfish,* **Chaetodon miliaris**, *is a schooling plankton feeder, sometimes seen in shallow water, but more common in deeper areas. The average size is 10 cm.*

144 - *The black and white striped pennantfish,* **Heniochus diphreutes**, *occurs in schools off reef dropoffs where it feeds on plankton. It reaches 18 cm in length.*

144▶

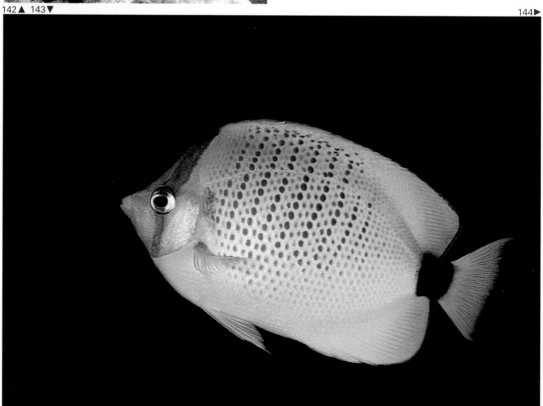

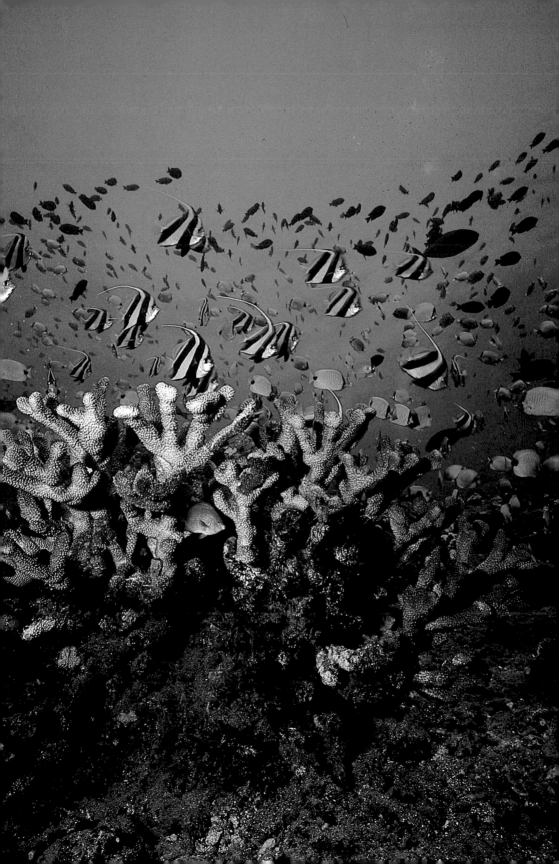

Jacks

The jack family includes a large number of fishes of different sizes and habits which are highly prized for food. Most of these fishes are active predators. Some medium-sized fishes like "akule" and "opelu" form schools near the shoreline and are commonly available at local fish markets. The larger species of jacks are generally referred to as "ulua" when over 10 lbs.

145 - *The blue jack,* **Caranx melampygus***, "omilu," is a predator which actively patrols reef areas feeding on smaller fishes. It may be solitary or in groups of 3 to 5. The young form schools inshore. The color is usually iridescent blue, but it can change to a dark color with gold flecks. Size: to 1 meter in length.*

146 - *The amberjack,* **Seriola dumerili***, "kahala," can be recognized by the dark, diagonal streak through the eye. This is a large species, reaching 2 meters. It is found in deeper water, to 150 meters, but comes into shallow areas to prey on smaller fish. This fish should not be eaten, as it is often toxic.*

147, 148 - *The white "ulua,"* **Caranx ignobilis***, is a large species, reaching more than 90 cm. in length. It may be solitary or form large schools. It is more common in deeper reef areas but is occasionally seen in shallow water.*

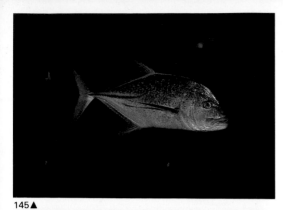

145▲

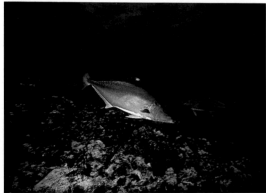

146▲ 147▼

148▶

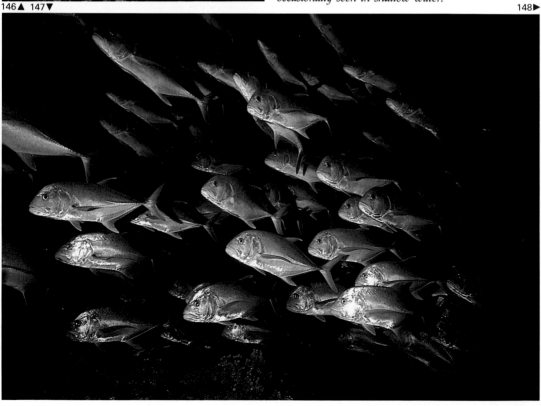

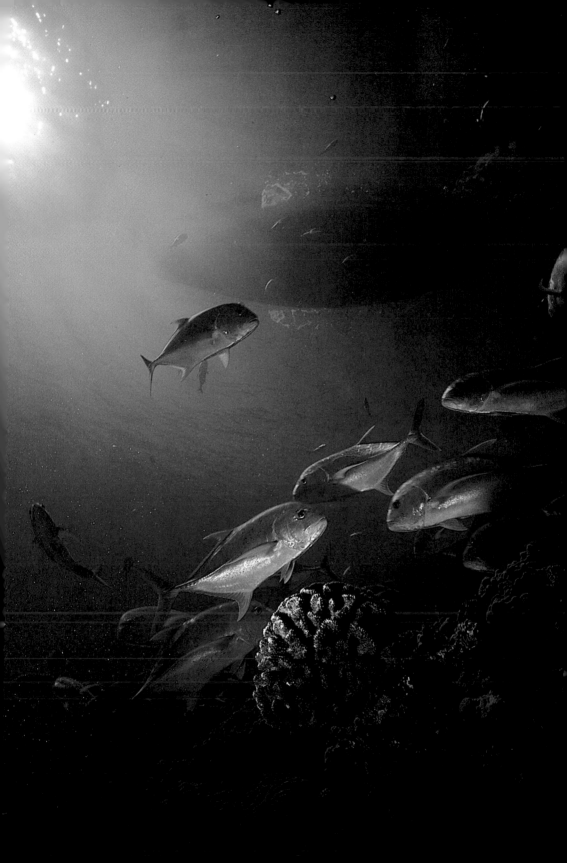

Damselfishes

Damselfishes are small fishes that attach their eggs to the reef and protect them during development. Most damselfish are either territorial or home-ranging.

149 - *The Pacific gregory,* **Stegastes fasciolatus**, *is a very territorial species that maintains and aggressively guards a patch of algae on the reef. It attempts to drive away other herbivores, especially schools of "manini." Average length is 10 cm.*

150 - *The young of the Hawaiian sergeant,* **Abudefduf abdominalis**, *"mamo," are found in tidepools. As they mature, they form aggregations and feed on plankton above the reef. The females lay purplish eggs on reef surfaces, seen here, and the males guard them, chasing away intruders. Size: averages 10-18 cm.*

151 - *The Hawaiian dascyllus,* **Dascyllus albisella**, *is black with a white spot on the side. The white spot can contract to the size of a dime or expand to cover the entire side. This species may be seen in aggregations in the water column feeding on plankton or in swarms around large heads of* **Pocillopora eydouxi**, *as seen here. Size: averages 10 cm.*

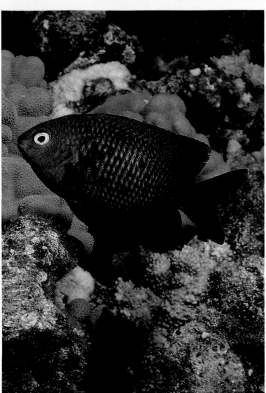

149▲ 150▼

151▶

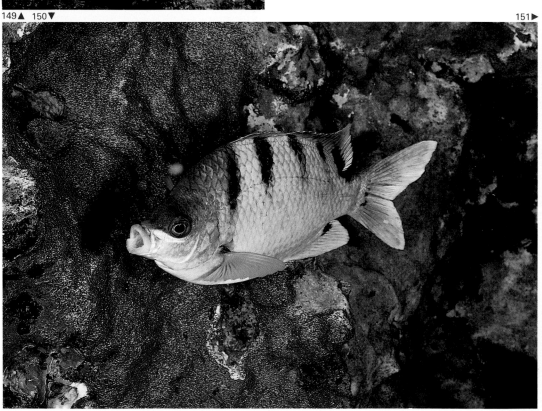

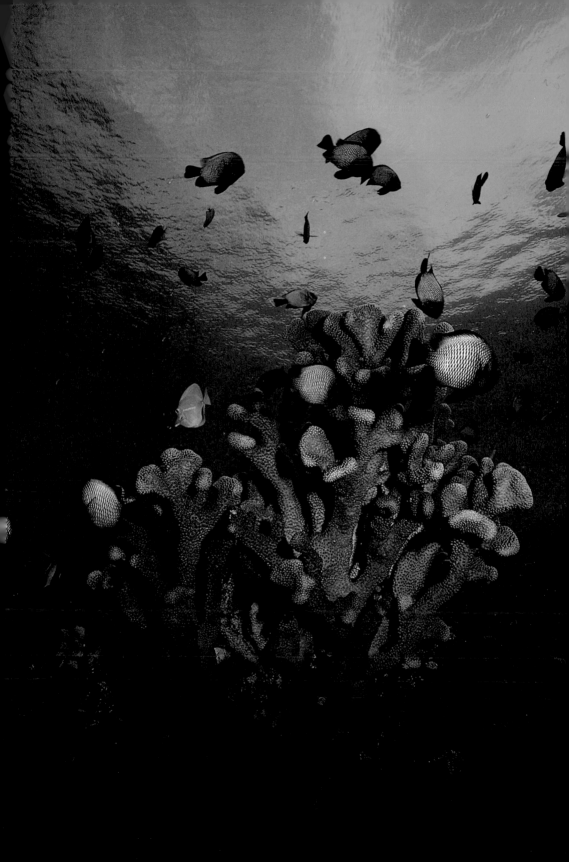

Wrasses

The wrasses are a large family of colorful tropical fishes. In many species juveniles, males, and females are different colors and patterns. Females are able to change sex and become males. Often these "terminal males" have a distinct color pattern and display breeding behaviors different from individuals born as males.

152, 153 - *The yellow-tail coris,* **Coris gaimard***, has three different color phases. The juvenile is red with white spots, the female is reddish with a yellow tail, and the male (below) is purplish-yellow with a yellow tail. Adults also have many small bright blue spots. As the juveniles mature the color change begins at the tail and proceeds forwards. They sleep in the sand at night. Size: large specimens reach 38 cm.*

154, 155 - *The rockmover,* **Novaculichthys taeniourus***, is a wrasse of moderate size that spends much of its time turning over rocks to find prey. It is a solitary inhabitant in areas of mixed sand and rubble, and it uses the sand as a hiding place. The juveniles (below) resemble pieces of floating seaweed. Size: to 30 cm. length.*

152▲ 153▼

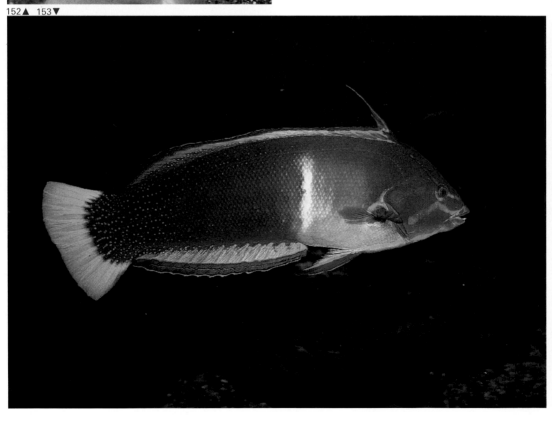

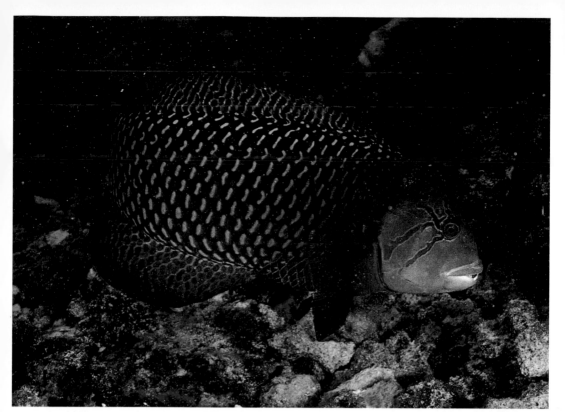

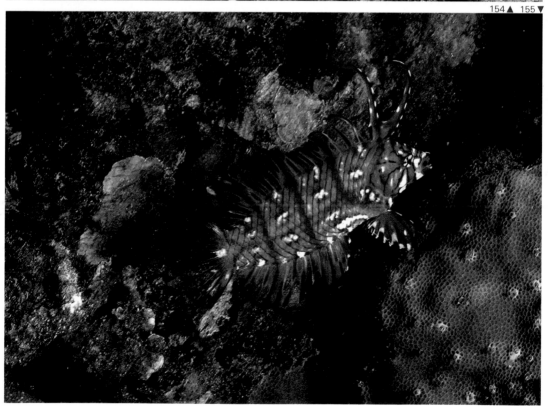

156 - *The Hawaiian cleaner wrasse,* **Labroides phthirophagus**, *eats parasites and diseased or damaged tissue it picks from other fishes. It sets up a "cleaning station" in a particular area of the reef, attracting fish in need of its services. There may be one to three cleaners at a station. Cleaners are small fish, about 7 cm in length.*

157 - *Even large eels, like the yellowmargin moray, use the services of the tiny cleaner wrasse.*

158 - *The saddle wrasse,* **Thalassoma duperrey** *is the most common wrasse in Hawai'i, and is found only here. A white strip on the side behind the orange saddle indicates that a female has changed sex and become a male. These large males have a better chance of breeding than do small ones. This species reaches about 25 cm.*

159 - *This saddle wrasse is investigating the underside of a slate pencil sea urchin. Saddle wrasses eat a wide variety of food types, including crustaceans, worms, brittle stars, sea urchins and snails.*

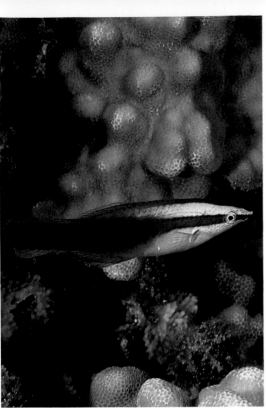

156▲ 157▼

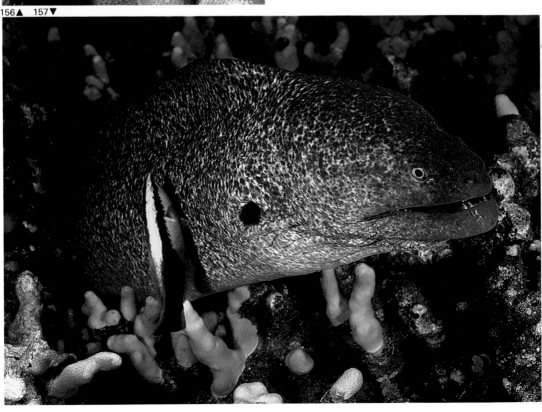

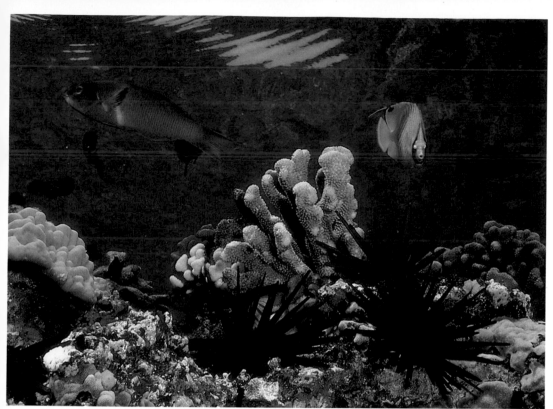

Parrotfishes

The parrotfishes, "uhu," are large, heavy-bodied fish with teeth that are fused into a hard beak, perfect for scraping the surface of dead coral for algae. The throat contains two ridged plates (pharyngeal teeth) which macerate coral rock scraped off with the algae. This material eventually passes out as coral sand. A large parrotfish can make a ton of sand a year. Males are blue or green, females are reddish-gray, and juveniles are pale gray. Parrotfish often form mucus cocoons at night.

160, 161 - *The male bullethead parrotfish,* **Chlorurus sordidus** *(below) can be recognized by the orange blush on the side, which is more intense near the tail. The females, seen being cleaned by a cleaner wrasse, are reddish-black with about six small white spots on the posterior half of the body or with a white tail bearing a single large black spot. Size: to 30 cm.*

162 - *The male of the spectacled parrotfish,* **Chlorurus perspicillatus**, *has a dark band over the snout. The female is reddish with a large white area at the base of the tail. This species is found only in Hawai'i. Size: to 60 cm.*

163 - *The redlip parrotfish,* **Scarus rubroviolaceus**, *is very large, reaching 70 cm. The front half of the body is darker than the back half.*

160▲ 161▼

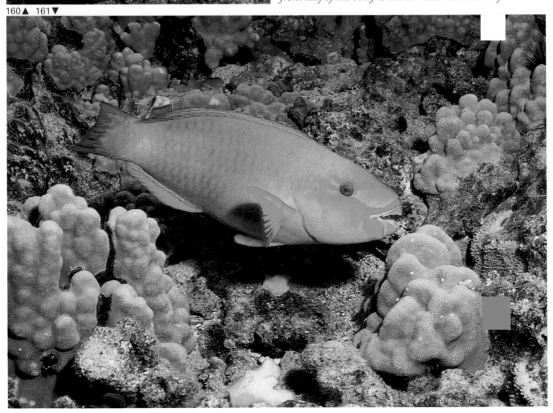

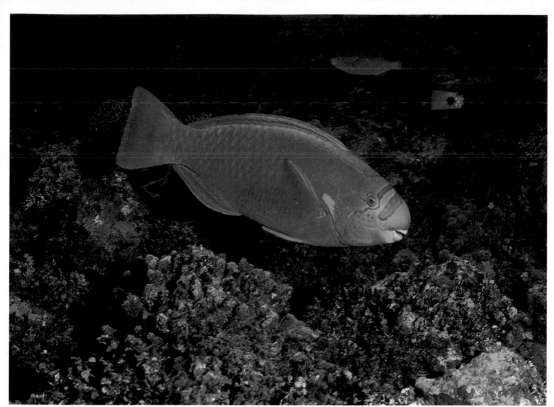

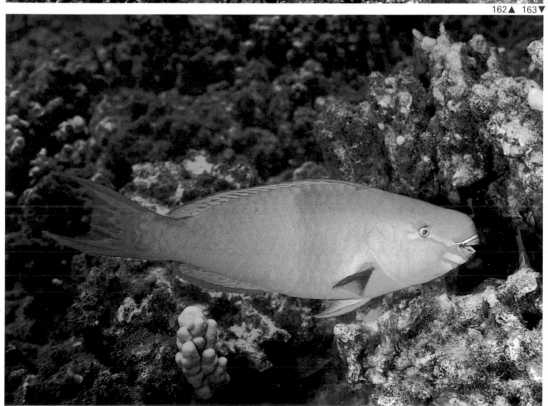

Hawkfishes

Hawkfishes are ambush predators that lie quietly on exposed areas of the reef and attack prey that come within close range.

164 - *The blackside hawkfish,* **Paracirrhites forsteri**, *is common in coral-rich areas, where it preys mainly on small fishes. It is not associated with any particular coral type. Size: to 25 cm.*

165 - *The arc-eye hawkfish,* **Paracirrhites arcatus** *is commonly found sitting motionless on lumps of coral, usually the cauliflower coral* **Pocillopora meandrina**.*This fish can be identified by the U-shaped arc over the eye. It feeds mainly on crustaceans. Size: to 15 cm.*

166 - *The small, colorful longnose hawkfish,* **Oxycirrhites typus**, *is found associated with black coral at depths between 15 and 90 meters. Here it rests over a bed of feathery hydroids. Size: 8-10 cm.*

164▲ 165▼

166▶

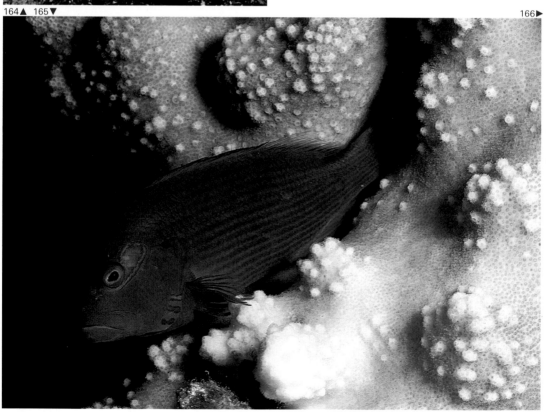

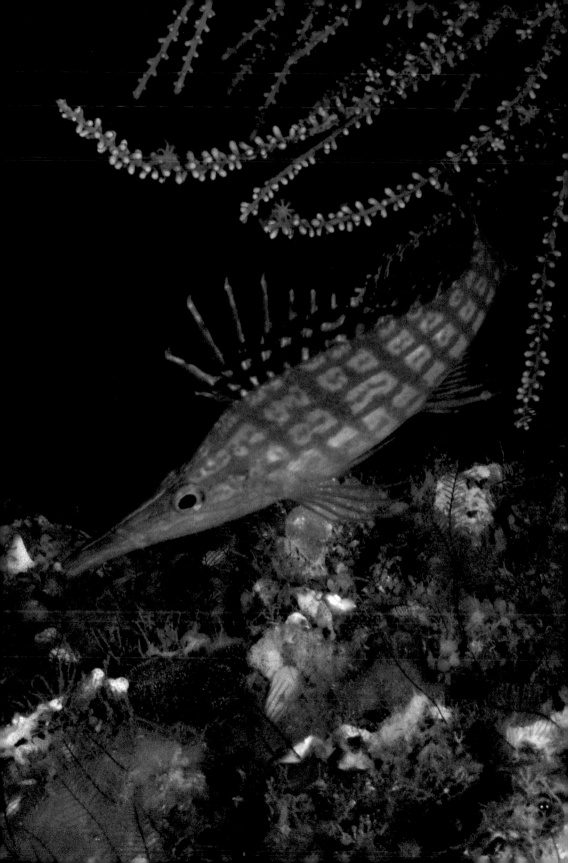

Surgeonfishes

The surgeonfishes are characterized by having spines at the base of the tail. Each side will have either one sheathed, hinged spine or two immovable spines. Most surgeonfish are algae feeders.

167 - The orangeband surgeonfish, **Acanthurus olivaceus**, "na'ena'e," commonly feeds in sandy areas. While its normal color is half dark gray and half light gray, it can change color to be all light gray or all black. The orange band at the shoulder is the identifying feature. Juveniles are bright yellow. Size: to 30 cm.

168 - The eye-stripe surgeonfish, **Acanthurus dussumieri**, "palani," can be identified by the large, white spine at the base of the tail. This species can change color from light blue to almost black. Size: to 40 cm.

169 - The yellowfin surgeonfish, **Acanthurus xanthopterus**, is a large species with a black spine and yellow pectoral fin. Size: to 50 cm.

170 - The achilles tang, **Acanthurus achilles**, "pāku'iku'i" is easily identified by the bright orange spot near the tail. This fish is common in surge areas. Size: averages 15-12 cm.

167▲

168▲ 169▼

170▶

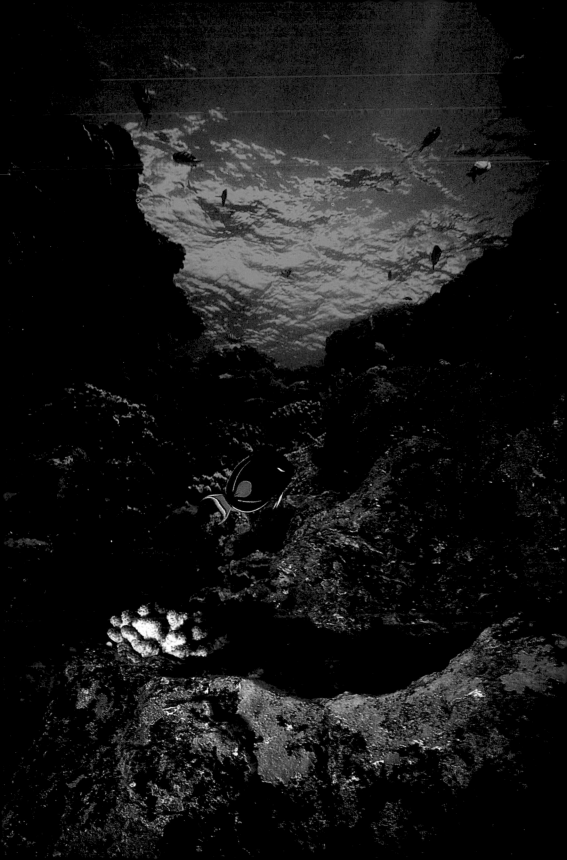

171 - *The whitebar surgeonfish,* **Acanthurus leucoparieus**, *"māiko-iko," is commonly found in shallow surge areas. It can be identified by the vertical white band behind the eye. Size: about 20 cm.*

172 - *The striped convict tang,* **Acanthurus triostegus**, *"manini," is found over coral or basalt below the surge zone. This is an extremely common fish in Hawai'i, and may be seen in very large schools with other types of surgeonfish, young parrotfish, and occasionally a trumpetfish. Juveniles are found in tidepools. Size: 10-18 cm.*

173 - *The goldring surgeonfish,* **Ctenochaetus strigosus**, *"kole," is dark with a gold ring around the eye. It has tiny moveable teeth for picking up fine sediment over rocks and dead coral from which it extracts and digests organic material. Size: about 15 cm.*

174 - *The yellow tang,* **Zebrasoma flavescens**, *"lau'i pala" feeds on fine, filamentous algae in exposed reef areas with low coral cover. The juveniles stay in a deeper zone dominated by the finger coral* **Porites compressa**. *At night the adults move to the finger coral zone for shelter. Size: averages 15 cm.*

171▲

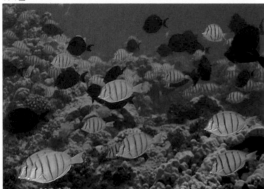

172▲ 173▼

174▶

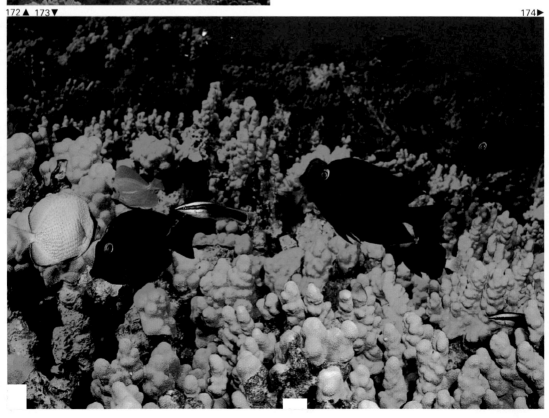

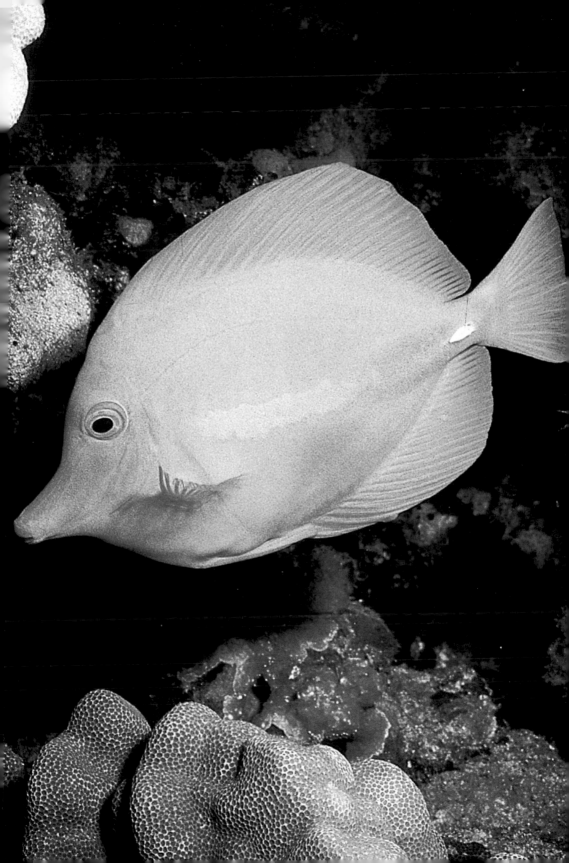

Unicornfishes are surgeonfishes with two fixed spines at the base of the tail.

175 - *The sleek unicornfish,* **Naso hexacanthus**, *"opelu kala," is a plankton feeder which occurs in large numbers in plankton-rich areas, usually around dropoffs. Size: averages 30 cm.*

176 - *The bluespine unicornfish,* **Naso unicornis**, *"kala," feeds on reef algae. It is easily recognized by the two bright blue spines at the base of the tail and the horn on the forehead. There are two other species of* **Naso** *in Hawai'i with horns on the forehead, but both have gray tail spines. Size: to 50 cm.*

177 - *The orangespine unicornfish,* **Naso lituratus**, *"uma-uma-lei," can be recognized by the two bright orange spines by the tail. The color of the body may vary from black to light gray. Size: to 38 cm.*

178 - *The moorish idol,* **Zanclus cornutus**, *"kihi-kihi," is closely related to the surgeonfishes. It is one of the most beautiful reef species and may occur singly, in small aggregations, or in large schools. It feeds on sponges which it picks out of crevices with its long snout. Size: to 23 cm.*

175▲

176▲ 177▼

178▶

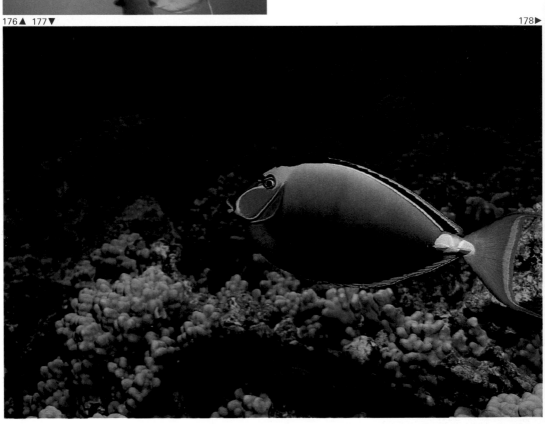

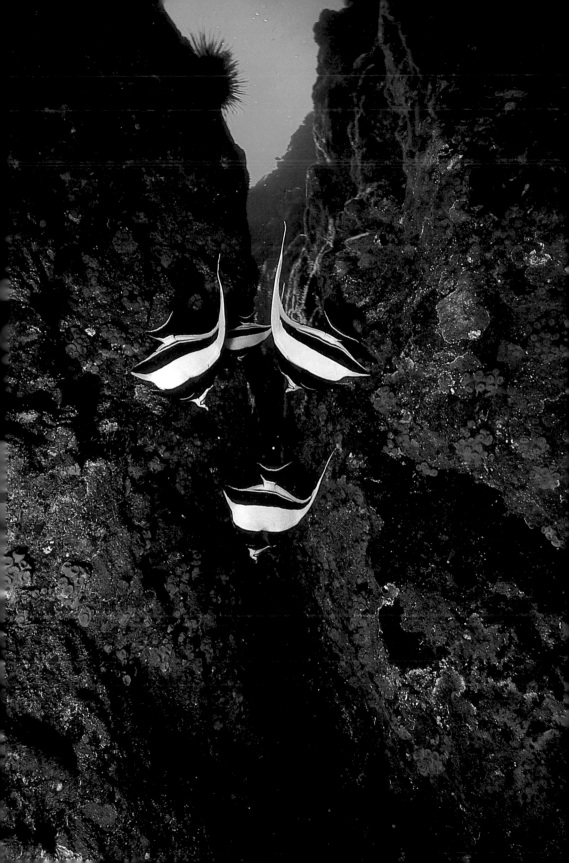

Scorpionfishes

Scorpionfishes are ambush predators. They lie motionless on the reef until suitable prey swims by, then quickly engulf it. This family is characterized by the presence of sharp, poisonous spines in the dorsal, anal, and pelvic fins.

179 - *The tiny leaf scorpionfish,* **Taenianotus triacanthus**, *may be red, yellow, or black. Algae grows in the skin, possibly to help in camouflage, and the skin is shed periodically. This species is further disguised from its prey by mimicking the motion of a leaf or piece of seaweed swaying back and forth in the current. Size: to 10 cm.*

180 - *The titan scorpionfish,* **Scorpaenopsis cacopsis**, *"nohu," may be reddish or mottled in gray tones. This is a large species which is found on the outer edge of the reef below 6 meters. Size: to 50 cm.*

181 - *The devil scorpionfish,* **Scorpaenopsis diabolus**, *"nohu," is commonly found in shallow reef areas. Its mottled gray color camouflages it perfectly with the bottom. The undersides of the pectoral fins are bright orange, yellow, and black, and these colors are exposed during movement. Size: to 30 cm.*

182 - *The Hawaiian turkeyfish,* **Pterois sphex**, *is found only in Hawai'i. It lives in quiet areas under rocks or in caves. Size: about 13 cm.*

179▲

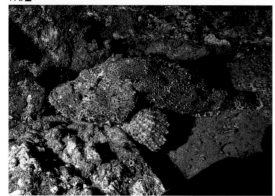

180▲ 181▼

182▶

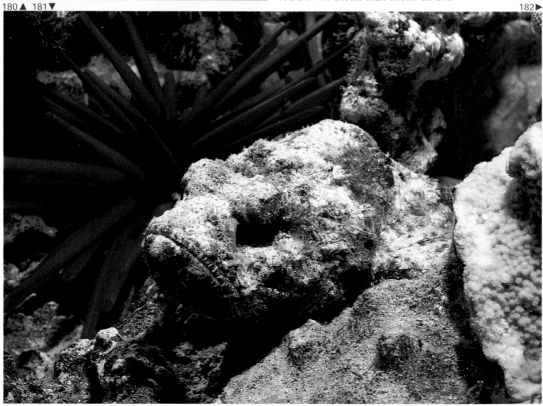

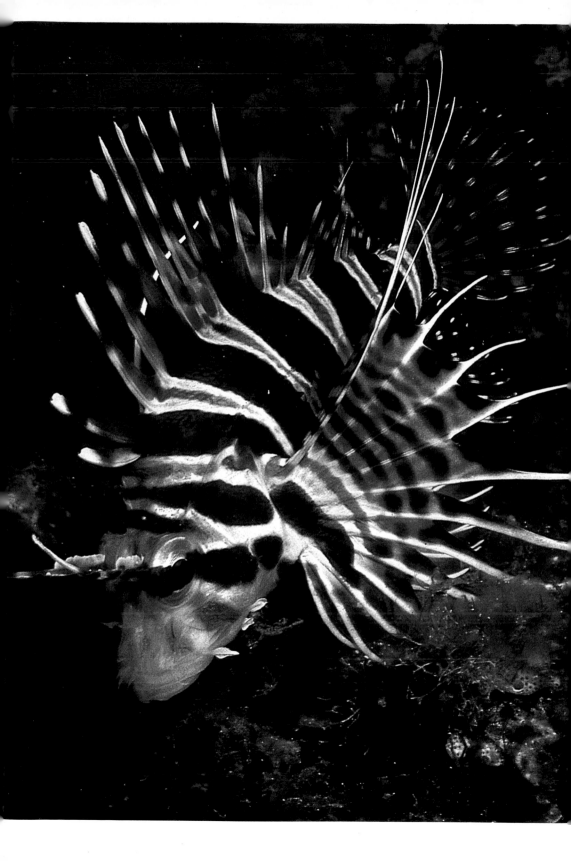

Unusual fishes

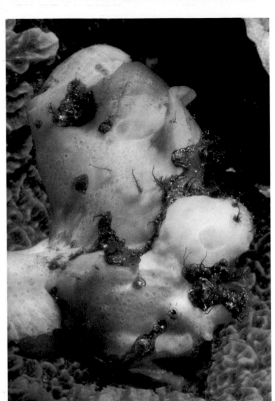

183 - *The frogfishes or anglerfishes are ambush predators that look like large chunks of sponge. In this photo the eye and mouth are at the bottom of the picture. Commerson's frogfish,* **Antennarius commersoni** *(left), is quite variable in color, ranging from light to dark with blackish spots and rings. The large, fleshy pectoral fins are used to prop the animal up and to walk slowly along the bottom. It reaches 20 cm. in length.*

184 - *The large spotted flounder,* **Bothus pantherinus,** *lies on its right side. In the tiny larval stages, flounders have eyes on each side of the head. During growth , however, the right eye migrates to the left (now top) side of the head. It lives in the sand where it is perfectly camouflaged. This species reaches 45 cm. in length. The smaller manray flatfish is seen more often than this species.*

185 - *The flying gurnard,* **Dactyloptena orientalis,** *crawls along the bottom on its pelvic fins, searching for food. The pectoral fins are large and fan-like; the first few fin rays are used to explore the sandy floor. Size: to 40 cm.*

183▲ 184▼ 185▶

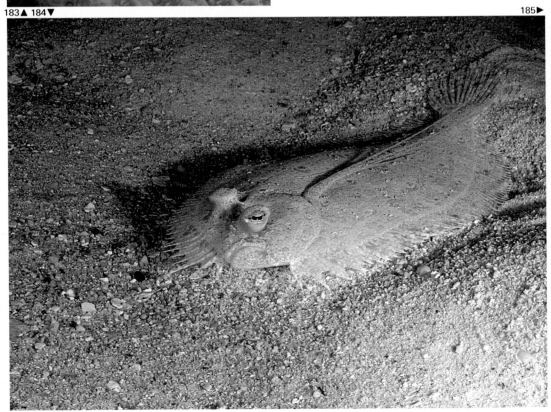

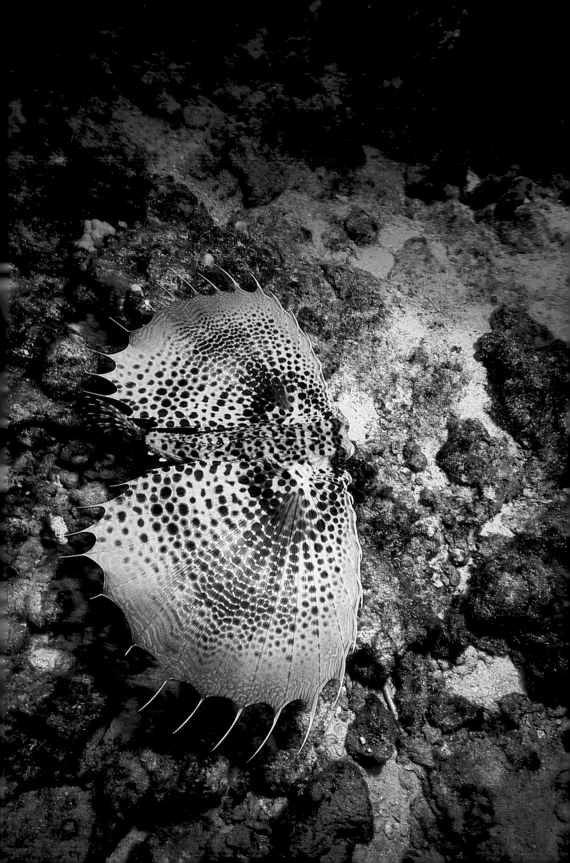

Triggerfishes

Triggerfishes are recognized by angular bodies, eyes set far back on the head, the lack of pelvic fins, and the use of the dorsal and anal fins in swimming.

186 - *The reef triggerfish,* **Rhinecanthus rectangulus**, *"humuhumunukunukuāpua'a", is common on shallow, surge-swept reefs. It is a solitary species that picks at food on the bottom, often expelling a cloud of silt from its gills during feeding. Size: to 23 cm. This species is the Hawaiian state fish. Photo by N. Harris.*

187 - *The pinktail triggerfish or durgon,* **Melichthys vidua,** *"humuhumu h'iu kole," is usually a solitary species, easily identified by the combination of black body and white fins. Size: to 23 cm.*

188 - *The lei triggerfish,* **Sufflamen bursa**, *"humuhumu lei," is a common species found in a variety of habitats. The color of the lei can change from dark to golden. Size: 15 to 20 cm.*

189 - *The black triggerfish or durgon,* **Melichthys niger**", *"humuhumu 'ele' ele", hovers in loose aggregations over the reef during the day, where it feeds on plankton and drifting algae. They seek shelter in holes in the reef at night and may use the same hole for many months. Size: to 35 cm.*

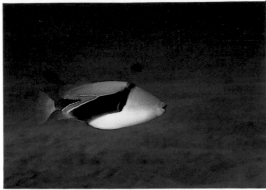

186▲

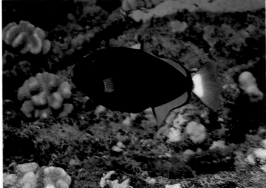

187▲ 188▼

189▶

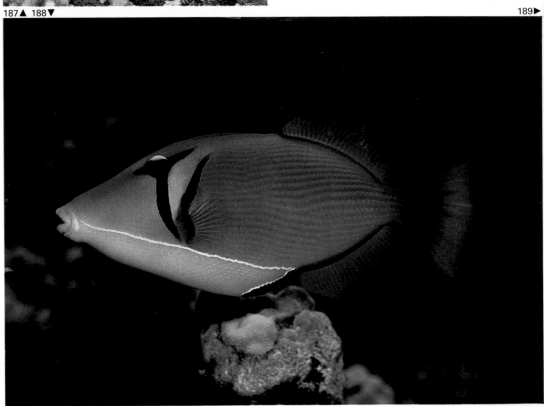

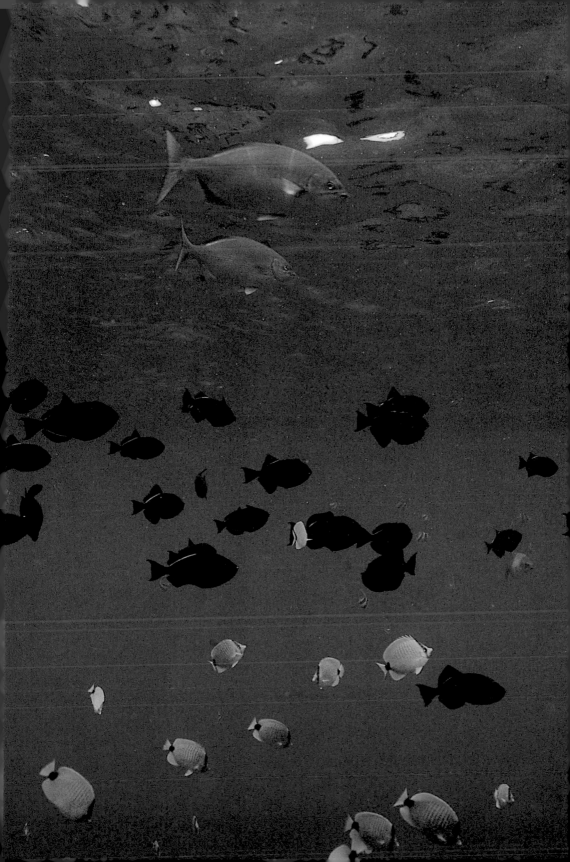

Filefishes

Filefishes are closely related to triggerfishes; they have only one dorsal fin spine on the head over the eye, as opposed to the triggerfishes' three. These spines can be raised or lowered at will. The Hawaiian name for filefishes is "o'ili."

190, 191 - The fantail filefish, **Pervagor spilosoma**, "o'ili—'uwi'uwi" is a small species which is found only in Hawai'i. Occasionally it occurs in explosive abundance, as it did in 1985. It is easily recognized by the large orange fan tail. This species is often seen engaged in an unusual behavior during which the single spine is raised up and down and the tail is flared. This may be a courtship or territorial display. Size: 10 cm. Photo by N. Harris. (below)

192 - The scrawled filefish, **Aluterus scriptus**, has a tail almost as long as the body. This fish is extremely compressed and has iridescent blue marks scattered over a gray or brown background. Two are seen here with several racoon butterflyfish. This is a large species, reaching 60 cm.

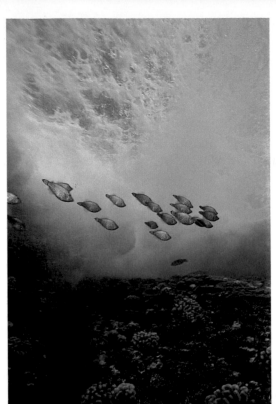

190▲ 191▼

192▶

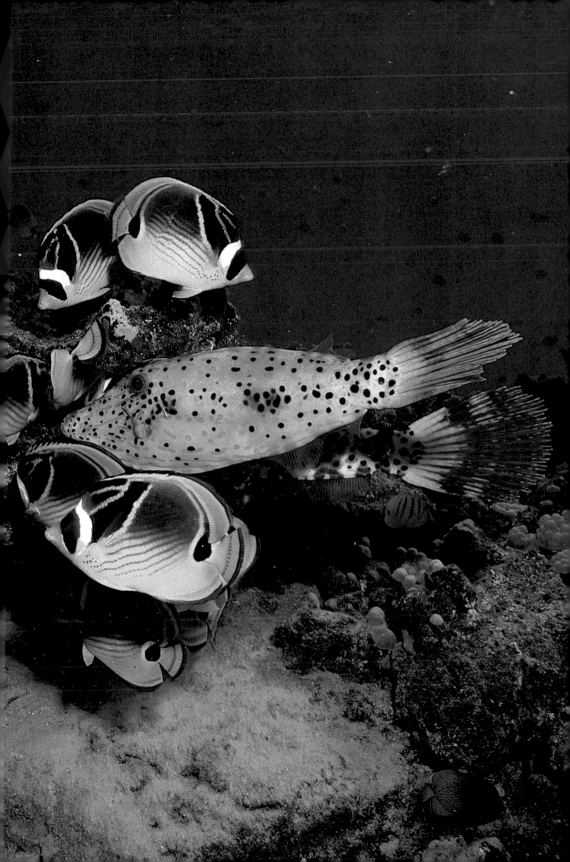

Pufferfishes

Pufferfishes have the ability to inflate their bodies with water when frightened, making it difficult for predators to swallow them or to dislodge them from holes. Some body parts are highly toxic and should not be eaten. Pufferfishes have strong, hard jaws that should be avoided if the fish is handled.

193, 194 - *The porcupinefish,* **Diodon hystrix**, *has a very wide, bony head and large cow-like eyes. This fish is covered with spines which become erect when the body is inflated. It feeds at night on crabs and snails, which are crushed by the fused teeth and strong jaws. It stays near the bottom and hides under reef overhangs. Porcupinefishes swim with the dorsal and anal fins, which are set back by the tail. Here it is seen both inflated and deflated. Size: to 50 cm.*

195, 196 - *The spotted puffer,* **Arothron meleagris**, *is dark brown with many small, white spots. The skin is covered with fine spines, giving it a fuzzy look when inflated. Size: to 33 cm.*

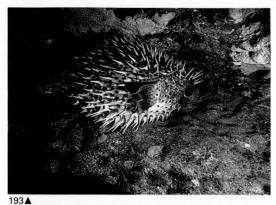

193▲

194▲ 195▼

196▶

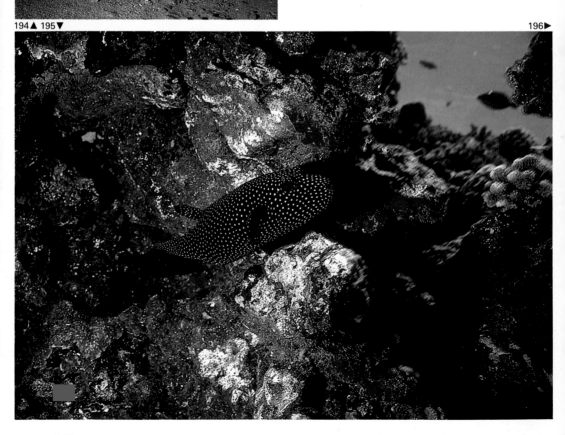

Trunkfishes

Trunkfishes have the body encased in a rigid box made of hexagonal plates. Gaps exist for the fins, mouth, anus, gills, and nostrils. They are slow swimmers, as they are unable to move their bodies and must rely solely on their fins for locomotion. As further protection, trunkfishes can exude a toxin when they are stressed which is able to kill fishes in the nearby area.

197 – 199 - *The spotted trunkfish,* **Ostracion meleagris**, *has two different color patterns. The males are blue on the sides with some yellow on the top, and the females (below) are black with white spots. This is a shy species which is common in shallow water. They swim close to the bottom and hide in reef crevices. The female trunkfish may be confused with the Hawaiian whitespotted toby; however, the trunkfish is square, while the toby is round. Size: to 15 cm.*

200 - *The redbar hawkfish,* **Cirrhitops fasciatus**, *sits patiently on the reef, waiting for something more tasty than a trunkfish to swim by. This small species is common in shallow water. The average size is 8 cm.*

197▲

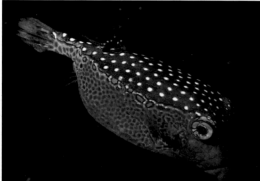

198▲ 199▼

200▶

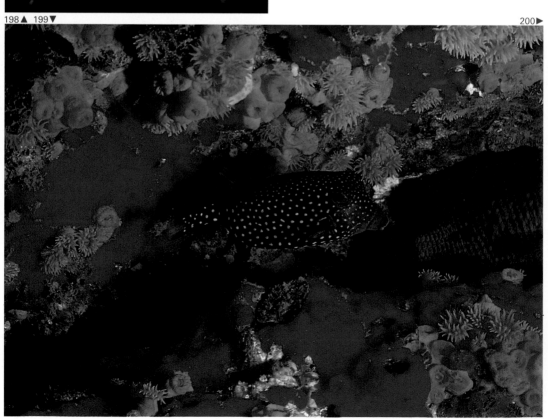

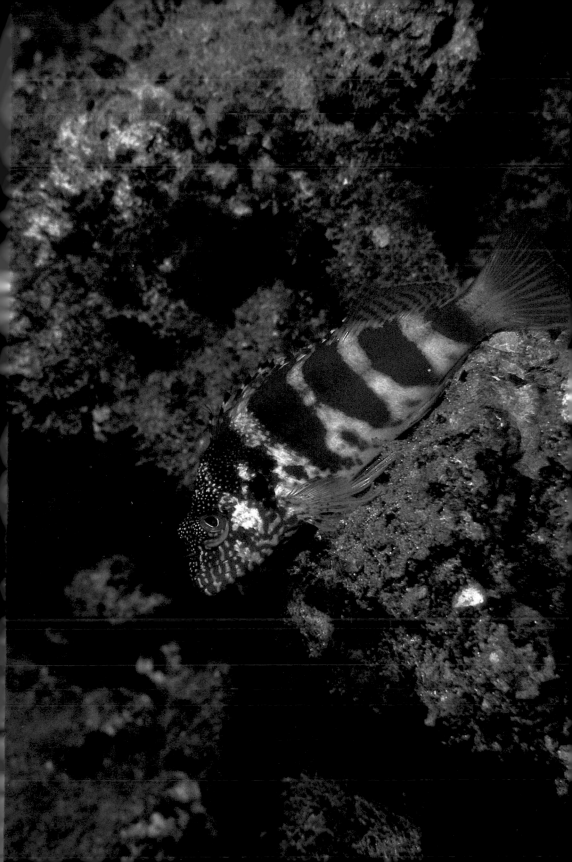

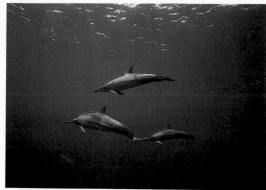

201▲

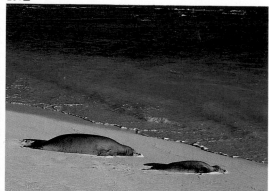

202▲ 203▼

Marine reptiles and mammals

Occasionally divers are fortunate enough to see larger animals such as turtles, porpoises, whales, or even Hawaiian monk seals. These animals are protected by law in Hawai'i and may not be killed or harassed.

201 - *Spinner dolphins,* **Stenella longirostris,** *are relatively common along Hawai'i's shorelines. They form large schools that are often seen in the same areas day after day. This is a small, athletic dolphin that is often seen jumping out of the water. It can be seen at Sea Life Park on O'ahu. Size: 1.5-2 meters.*

202 - *The Hawaiian monk seal,* **Monachus schauinslandi,** *is usually found only in the Northwestern Hawaiian Islands but is occasionally seen on the main islands. Photo by A. Fielding.*

203 - *It is against the law to even touch the green sea turtle,* **Chelonia mydas.** *Green sea turtles breed and nest in the remote Northwestern Hawaiian Islands. Mature animals weigh between 200 and 375 pounds.*

204 - *The humpback whale,* **Megaptera novaeangliae,** *migrates to Hawai'i or Mexico during the winter to breed and calve, and back to Alaska in the summer to feed. Size: to 16 meters.*

204▶

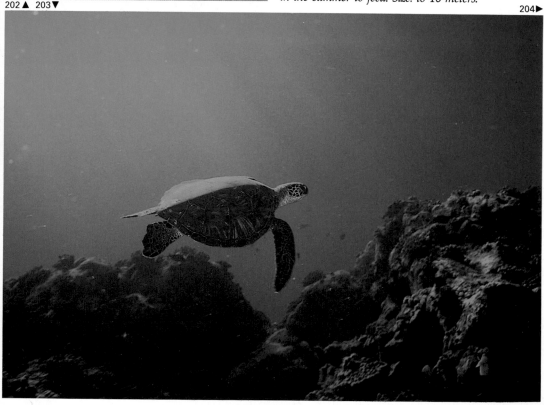

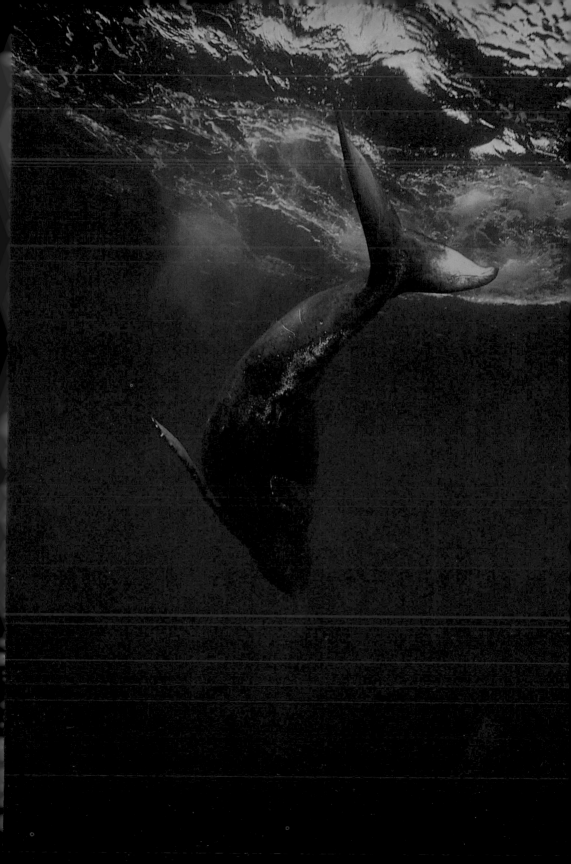

INDEX

Suggested Readings on Hawaiian Marine Life

Bertsch, H. and S. Johnson, 1981. *Hawaiian Nudibranchs*, The Oriental Publishing Co., Honolulu, HI. 112 pp.

Carpenter, R. and B., 1981. *Fish Watching in Hawaii*, Natural World Press, San Mateo, CA. 120 pp.

Fielding, Ann, 1979. *Hawaiian Reefs and Tidepools*, The Oriental Publishing Co., Honolulu, HI. 103 pp.

Hobson, E. and E.H. Chave, 1972. *Hawaiian Reef Animals*, University of Hawaii Press, Honolulu, HI. 136 pp.

Kay, E.A., 1979. *Hawaiian Marine Shells*, Bernice P. Bishop Museum Special Publication 64(4), Bishop Museum Press, Honolulu, HI. 653 pp.

Magruder, W.H. and J. Hunt, 1979. *Seaweeds of Hawaii*, The Oriental Publishing Co., Honolulu, HI. 116 pp.

Randall, John E., 1985. *Guide to Hawaiian Reef Fishes*, Treasures of Nature, Kaneohe, HI. 79 pp.

Tinker, Spencer W., 1978. *Fishes of Hawaii*, Hawaiian Service Inc., Honolulu, HI. 532 pp.

Titcomb, Margaret, 1972. *Native Use of Fish in Hawaii*, University of Hawaii Press, Honolulu, HI. 175 pp.

Titcomb, Margaret, 1978. *Native Use of Marine Invertebrates in Old Hawaii*, University of Hawaii Press, Honolulu, HI. 61 pp.

Scientific Editor: Bernard SALVAT